CONTENTS

ACKNOWLEDGMENTS

This book draws upon many sources to trace the history of Philadelphia's Washington Square. I wish to acknowledge and thank all whose images, information, and insights made this endeavor possible.

The Print and Pictures Department of the Free Library of Philadelphia, headed by Karen Lightner, proved a rich lode of historical images. Similarly productive were Temple University's Urban Archives and the Philadelphia Department of Records, which generously provided high-resolution digital versions of photographs from the Philadelphia City Archives. These and other historic photographs are available to the public at PhillyHistory.org, an online database. The Library of Congress, especially its Historic American Buildings Survey (HABS), supplied many images. The N. W. Ayer archive at the Smithsonian's National Museum of American History was invaluable in tracking that company's history.

Other sources included the Library Company of Philadelphia, Historical Society of Pennsylvania, Friends Historical Library of Swarthmore College, Pennsylvania Hospital Archives, Fairmount Park Commission, Philadelphia Archdiocesan Historical Research Center, Pennsylvania Bible Society, Winterthur Library, Athenaeum of Philadelphia, and Philadelphia Architects and Buildings database. Companies historically resident on the square also were generous. These included the Farm Journal, which graciously permitted access to its historical records; Lippincott Williams and Wilkins, a unit of Wolters Kluwer Health; W. B. Saunders division of Elsevier; Penn Mutual and ACE Group insurance companies; and George T. Bisel Company. Images concerning Lippincott and Saunders are used with permission from the excellent histories of these companies noted in the bibliography. Any other individually uncredited images are from my collection.

I am indebted to Independence National Historical Park, where I am a volunteer, for providing access to its archives and other resources in support of this project. In particular, I wish to thank Susan Edens, who first gave me the opportunity to study Washington Square, and Anna Coxe Toogood, who read the manuscript and offered valuable suggestions. Thanks also to Paula Etkin and to Karen Stevens and Andrea Ashby for help with the images.

Among works noted in the bibliography, Francis James Dallet's *An Architectural View of Washington Square* and Denise R. Rabzak's *Washington Square: A Site Plan Chronology 1683–1984* were especially useful.

IMAGES
of America

PHILADELPHIA'S
WASHINGTON SQUARE

IMAGES
of America

PHILADELPHIA'S
WASHINGTON SQUARE

Bill Double

ARCADIA
PUBLISHING

Published by Arcadia Publishing
Charleston SC, Chicago IL, Portsmouth NH, San Francisco CA

Printed in the United States of America

Library of Congress Control Number: 2009922696

For all general information contact Arcadia Publishing at:
Telephone 843-853-2070
Fax 843-853-0044
E-mail sales@arcadiapublishing.com
For customer service and orders:
Toll-Free 1-888-313-2665

Visit us on the Internet at www.arcadiapublishing.com

To Patricia

INTRODUCTION

Philadelphia's Washington Square, an unassuming 6.6-acre plot near the nation's birthplace, has been a focal point of the city's history for over 300 years. Its origin may be traced to the city plan drawn for Pennsylvania founder William Penn in 1683 by surveyor Thomas Holme. Southeast Square—it was renamed for Washington in 1825—was one of four squares laid out equidistant from a central square to provide open space for the residents of Penn's "green country town." Thus, Southeast Square predated both its historic neighbor, Independence Hall, completed as the Pennsylvania State House in 1748, and the birth of its present namesake George Washington in 1732.

The square is bounded by Walnut Street on the north, South Washington Square on the south, Sixth Street on the east, and West Washington Square on the west. The square's western and southern boundaries have been renamed over the years. West Washington Square has been Little Seventh Street, Washington Street, and Columbia Avenue; South Washington Square also has been designated Locust Street and Washington Street.

Although the Southeast Square lay barely six blocks from Penn's settlement on the Delaware River, it remained near the perimeter of the settled city for most of its first century. Philadelphia's development did not immediately proceed westward as the founder envisioned, instead tracking north and south along the river. Youths shot wild ducks at a pond near the square's southwest corner where the First Presbyterian Church later stood. The pond fed a creek that ran downhill across the square toward Sixth Street, where it joined another stream that crossed the square's northeast corner. These waterways were later filled and the ground leveled.

In 1706, Penn's commissioners granted the city's common council a patent to use Southeast Square as a burial ground for strangers, or potter's field. Little did the council anticipate the grim role the square would later play as a mass grave site. An estimated 2,000 or more bodies were buried in the square, many of them Revolutionary War soldiers, Continentals, and British. They died while held at the Walnut Street Prison built on the east side of the square in 1775 or in nearby Pennsylvania Hospital. After visiting the square, John Adams plaintively wrote to his wife Abigail that the sight of the mass graves was enough to "make a heart of stone melt away." Yellow fever victims, the destitute, and common criminals also found a last resting place in the square.

During its early years, the square, known for its lush crop of grass, was leased by the city as a pasture. It also was used by black residents, free and enslaved, as a burial ground and meeting place where they might celebrate the rituals of their African homelands, particularly at holidays. However, the square's location in the path of urban growth dictated that it would not remain a pasture or potter's field. In 1795, the city ordered the square closed as a burial ground and that

it be improved with trees and public walks around it. But in 1813, the city was still renting the square for grazing, and a cattle market remained at its western end until 1815.

Although the square was laid out as a public park, its residential development, unlike many of its European counterparts, did not follow a predetermined plan. Its development relied instead on speculative building. Before the dawn of the 19th century, real estate developers of the day were buying parcels of land around the square. In 1794, John Swanwick purchased a tract along the north side of Walnut Street between Sixth and Seventh Streets, which he sold off in lots. Residential development soon followed on these parcels and other Walnut Street sites as well. "Modern houses," designed by Benjamin Henry Latrobe and dubbed Sansom's Row, were offered for rental in 1799 at $200 per year. On the south side of Walnut between Seventh and Eighth Streets, a row of simple red-painted frame houses occupied by tradesmen was demolished about 1807. In their place rose York Row, a series of larger, more stylish town houses.

The new residents successfully petitioned the city to improve their collective front yard. Starting in 1816, the square was cleaned up, landscaped, and laid out as a formal park. Some 200 trees of many varieties were planted along circular gravel walks. However, the square was not opened as a public promenade until 1825. The square would be redesigned again in 1882, 1915, and 1957, when it became the site of a memorial to the unknown soldier of the Revolution.

The Washington Square neighborhood evolved as well. A collection of rude huts on the outskirts of the city gave way to a prosperous community of homes around the square by the mid-19th century. But toward the end of the 19th century, the area's "solid citizens" were moving out, encouraged by improved transportation lines to the west. Their leaving, combined with the city government's abandonment of area buildings for its new city hall, depressed property values. Apartment conversion and cheap rents made the area attractive to the influx of immigrants entering the country at the time, and overcrowding became a problem. But stagnating property values proved inviting to businesses that wished to remain and expand in the central city.

Washington Square became an attractive locale for the publishing and advertising industries in particular. Some of the nation's most widely read books and journals were produced on its borders. Civic-minded business leaders such as *Farm Journal* editor Charles F. Jenkins took the lead in working with the city to improve both Washington Square and its neighbor, Independence Square. Although Washington Square was redesigned and relandscaped in 1915, the area's residential decline continued in the first half of the 20th century, marked by suburban migration and property deterioration.

The slide was arrested in the 1950s when the city initiated an ambitious improvement program for the historic district and residential area east of the square that became known as Society Hill. However, the new preservation ethic did not hold sway around Washington Square. Instead, high-rise living arrived in the form of the 31-story Hopkinson House apartments in 1963 and two 25-story Independence Place condominium buildings starting in 1982. The former was built on ground cleared by demolition of the 1821 First Presbyterian Church and the latter on the site of several historically significant houses.

Today, nearly 200 years after its rustic ambiance lured 19th-century Philadelphians, the square is attracting a new generation of urban residents. This time they covet the area's stylish condominiums and upscale amenities, symbols of a renewed interest in city living. The sturdy edifices that once housed the likes of publishers J. B. Lippincott and W. B. Saunders and advertising giant N. W. Ayer are being recycled to satisfy this demand. Throughout the years since its opening as a public park in 1825, Washington Square has steadfastly fulfilled its founder's purpose by affording Philadelphians and visitors alike the pleasure of a quiet moment in the midst of a busy city.

One

FROM POTTER'S FIELD TO PROMENADE
1683–1830

Southeast Square was one of five plazas in William Penn's 1683 plan designated as public parks for residents of Philadelphia. Yet more than 100 years elapsed before Southeast Square achieved the founder's objective. The city decreed the square a potter's field (burial ground for strangers) in 1706. And for many years Southeast Square remained unsettled, an uneven tract where boys hunted ducks on a pond, cattle grazed, and black residents celebrated holiday rituals. By the latter part of the 18th century, however, Philadelphia was growing rapidly and settlement that initially clung close to the Delaware River pushed westward toward the square.

Early buildings around Southeast Square included the Loganian Library (1745) on the northwest corner of Sixth and Walnut Streets, the Pennsylvania State House (1748) in the block diagonally northeast of the square, and the foreboding Walnut Street Prison (1775) on the east side. During the Revolution, British and American soldiers who died while imprisoned there were buried in mass graves in the square. The prison played host to a happier event in 1793. Frenchman Jean Pierre Blanchard ascended in a hydrogen-filled balloon from the prison yard, the first aeronautical flight in America.

In the 1790s, development proceeded apace as speculators acquired land around the square and either sold it off as building lots or erected terraces (rows) of houses. In 1795, the city closed the square's potter's field and ordered trees planted and walks around its borders. These improvements encouraged residential development on all sides of the square in the ensuing years.

More ambitious plans for the square proper took shape in 1815. The city ordered the cattle market closed and hired a decorative painter to transform the square into a park. He configured the square as a web of circular gravel walkways intersected by diagonals from the four corners. To complete the design, a veritable arboretum of trees—domestic and foreign—was planted in the square and a perimeter fence installed. Although the park was completed by 1817, it was not fully accessible until 1825, when the square was opened as a public promenade.

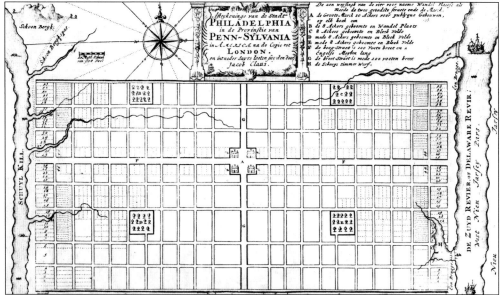

This plan for William Penn's "green country town" was drawn by his surveyor Thomas Holme in 1683. Penn hoped this grid would guide orderly development with individual houses separated from their neighbors by green space, in contrast to cramped and dangerous European cities. Parkland was provided by a central square and four satellites, equidistant from the center. Southeast (later Washington) Square lies in the middle of the lower right quadrant. (Free Library of Philadelphia, Print and Picture Collection.)

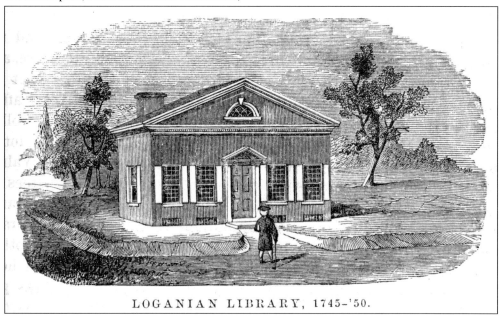

LOGANIAN LIBRARY, 1745-'50.

The Loganian Library at the northwest corner of Sixth and Walnut Streets was the first building bordering Southeast Square. It was built in 1745 by amateur architect James Logan to house his private collection of books. The books were moved to the Library Company on Fifth Street in 1793. The building housed homeless children during the yellow fever epidemic of 1793. (Library of Congress, Prints and Photographs Division.)

The main hall of the Georgian-style Pennsylvania State House was completed in the block diagonally northeast of Washington Square in 1748. The familiar bell tower was added in 1753. Although the Declaration of Independence was signed here in 1776, the name Independence Hall was not generally applied to the entire building for about 100 years. This photograph dates from 1873. (Free Library of Philadelphia, Print and Picture Collection.)

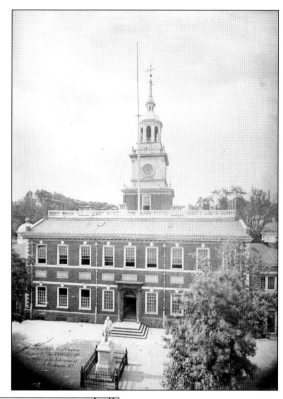

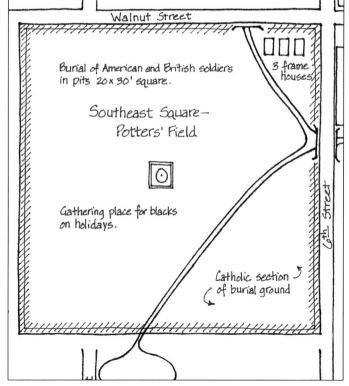

By the Revolutionary War, Southeast Square was the domain of the detained and the dead. The massive Walnut Street Prison opened in 1776 on the square's east flank. The square proper for 70 years had been the city's official burial ground for strangers. Trenches would soon be dug on the north side as mass graves for the stacked coffins of 2,000 or more Continental and British soldiers. (Independence National Historical Park.)

During the Revolution, Continental and British soldiers who died in the Walnut Street Prison (below) and Pennsylvania Hospital were buried in mass graves in Southeast Square. After visiting the square in 1777, John Adams (left) plaintively wrote to his wife Abigail, "I have spent an hour this morning in the Congregation of the dead. I took a walk into the 'Potter's Field,' a burying ground between the new stone prison and the hospital, and I never in my whole life was affected with so much melancholy. The graves of the soldiers, who have been buried, in this ground . . . are enough to make the heart of stone to melt away! The sexton told me that upwards of two thousand soldiers had been buried there, and by the appearance of the grave and trenches, it is most probable to me that he speaks within bounds." (Left, Library of Congress, Prints and Photographs Division; below, Free Library of Philadelphia, Print and Picture Collection.)

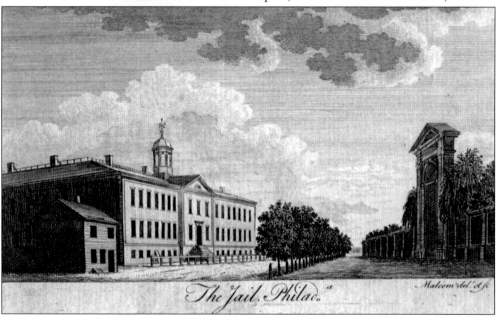

The Jail, Philad.ᵃ Malcom del.ᵗ et sc.

When Pennsylvania needed to raise money for construction of the Walnut Street Prison on Southeast Square, it employed a time-honored funding device—the printing press. Special notes (right) were issued in various denominations in 1775 to pay for construction. The notes featured a drawing of the prison, along with an ominous warning: "To Counterfeit is Death." (The Library Company of Philadelphia.)

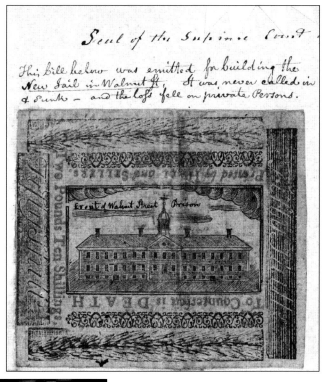

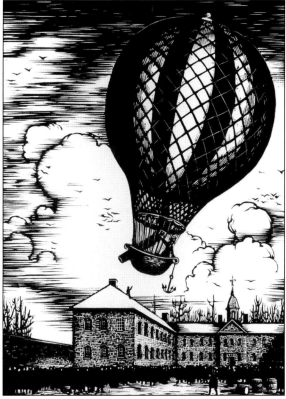

The Walnut Street Prison on Southeast Square provided the unlikely launch site for the first air flight in America. In 1793, French aeronaut Jean Pierre Blanchard ascended from the prison yard in a hydrogen-filled balloon amid a crowd of festive spectators. Blanchard carried a letter of introduction from Pres. George Washington, himself an onlooker. Blanchard's craft landed near Woodbury, New Jersey. (Philadelphia City Archives, PhillyHistory.org.)

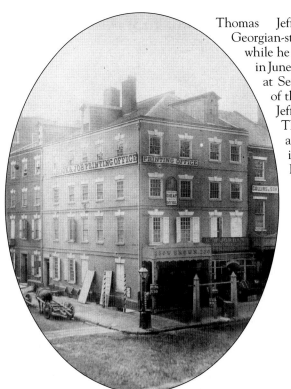

Thomas Jefferson occupied rooms in this Georgian-style house near Washington Square while he wrote the Declaration of Independence in June 1776. The home of bricklayer Jacob Graff at Seventh and Market Streets on the edge of the Colonial city, shown in 1856, offered Jefferson the seclusion needed for this task. The Graff House was demolished in 1883 and rebuilt by the National Park Service in 1975. (Free Library of Philadelphia, Print and Picture Collection.)

Carpenters' Hall at Fourth and Chestnut Streets was designed by Robert Smith, architect of the Walnut Street Prison. It was built 1770–1774 by the Carpenters' Company, a craftsmen's guild. The hall hosted the First Continental Congress, which listed the grievances of the American colonies with British rule in 1774. Still owned today by the Carpenters' Company, the hall may be visited as a National Park Service site. (Library of Congress, Prints and Photographs Division.)

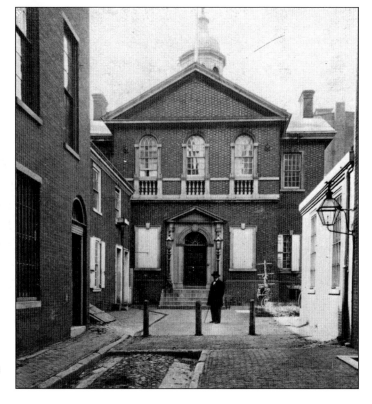

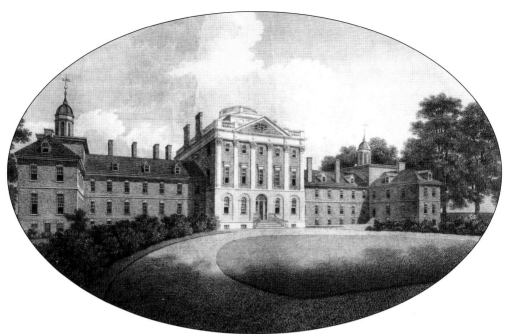

Many of the Revolutionary War soldiers buried in the mass graves of Washington Square died while patients at the new nation's first hospital. Pennsylvania Hospital cared for both Continental army and British soldiers, the latter during their occupation of the city. The hospital was founded by Benjamin Franklin and Dr. Thomas Bond in 1751. Five years later the hospital admitted the first patients to its newly constructed Pine Building (c. 1802 engraving above) near the square at Eighth and Pine Streets. The architect was Samuel Rhoads. The hospital's ground floor contained the cells for insane patients. The second floor was the men's ward and the third floor the women's. The original apothecary (c. 1898 photograph below) has been converted to meeting space. (Pennsylvania Hospital Archives.)

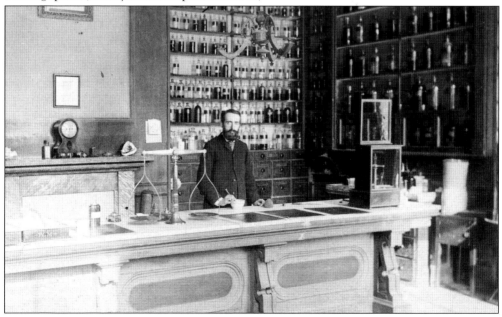

The "dreaded circular room" was Pennsylvania Hospital's operating room from 1804 to 1868. Surgery was performed between 11:00 a.m. and 2:00 p.m. on sunny days to maximize available light. The public was encouraged to witness operations from the room's 180 seats. Before anesthesia became available, patients were sedated with opium, strong drink, or a sharp rap on the head with a mallet. (Pennsylvania Hospital Archives.)

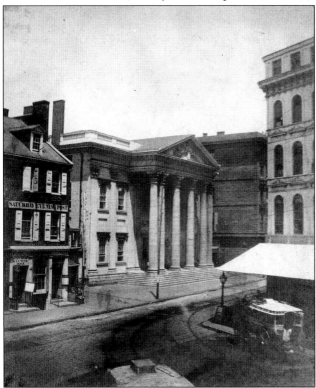

The First Bank of the United States on Third Street below Chestnut Street (center left) was completed in 1797. The bank itself existed from 1791 to 1811. Its charter was not renewed due to public suspicion over its motives. The building was taken over by commercial banker Stephen Girard and later housed National Park Service offices. Notice the Saturday Evening Post (left of bank), later purchased by publisher Cyrus Curtis, in this 1859 photograph. (Free Library of Philadelphia, Print and Picture Collection.)

Merchant Robert Morris (right), "Financier of the Revolution" and signer of the Declaration of Independence and Constitution, died penniless and forgotten, following his release in 1801 from the Walnut Street Prison debtors' annex. After emigrating from England, Morris apprenticed with a shipping firm. He was a partner by age 20 and soon became one of Philadelphia's most influential citizens. As a member of the Continental Congress, he raised funds for the Revolution. Thomas Paine accused him of war profiteering, but Congress exonerated him. After the war, Morris's speculation in western lands went awry and creditors demanded his arrest. He was forced to abandon the lavish town house he was building on Chestnut Street and remanded to debtors' prison in 1798, where George Washington visited him. His unfinished house (below) became known as "Morris's Folly." (Right, Library of Congress; below, Free Library of Philadelphia, Print and Picture Collection.)

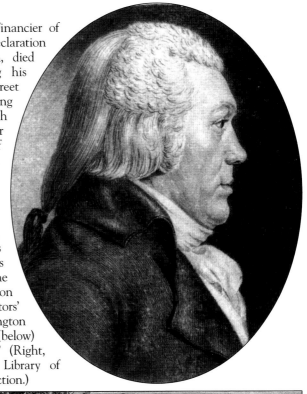

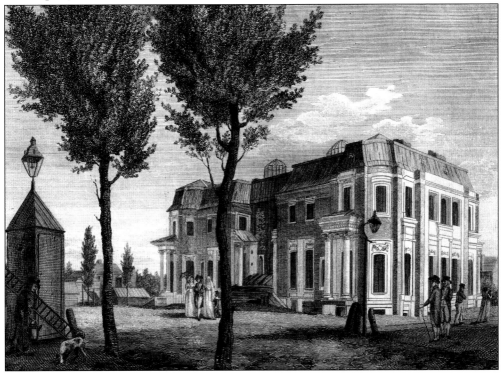

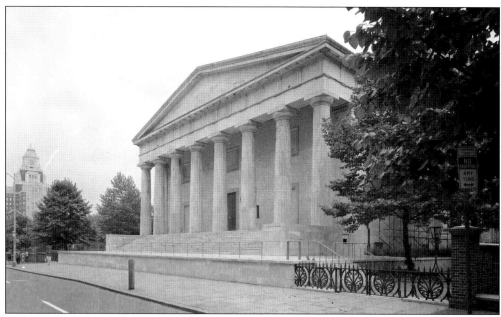

The Greek Revival–style Second Bank by architect William Strickland has stood at 420 Chestnut Street since 1824. It succeeded the First Bank of the United States (1791–1811) but soon sparked an epic political conflict between Pres. Andrew Jackson and bank president Nicholas Biddle. Jackson refused to recharter the bank, and it closed in 1836. Today the building houses a National Park Service portrait gallery of early Americans. (Library of Congress, HABS.)

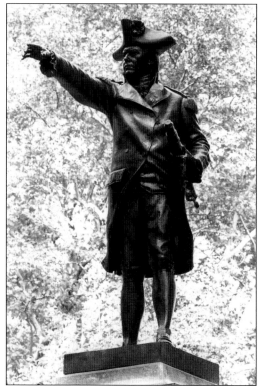

Commodore John Barry, the Irish immigrant who became a Revolutionary War hero and father of the American Navy, was an early resident of Southeast Square. In 1800, he occupied a house on South Sixth Street south of the Walnut Street Prison. This statue of Barry, a gift of the Friendly Sons of St. Patrick in 1907, stands behind Independence Hall. (Independence National Historical Park.)

The ramshackle structure below being laboriously hauled by a team of mules past the Walnut Street Prison in 1794 appears an unlikely house of worship. But it would shortly become the home of the Bethel African Methodist Episcopal Church, one of the nation's first black churches. Rev. Richard Allen (right) purchased the old blacksmith shop and had it rolled several blocks to a lot at Sixth and Lombard Streets. Allen held services there while raising funds for a permanent structure. The former slave and charismatic preacher, became disaffected from St. George's Methodist Church, which degraded black members. The potter's field in Southeast Square was not unfamiliar to Allen. During the yellow fever epidemic of 1793, he heeded the call for blacks to assist. They cared for the sick and buried the dead—many in the square's mass graves. (Right, Mother Bethel African Methodist Episcopal Church; below, Library of Congress, HABS.)

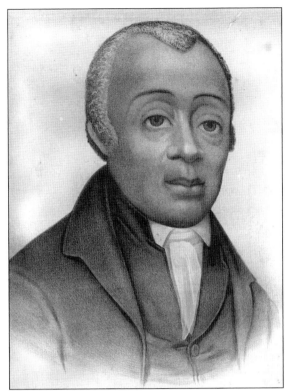

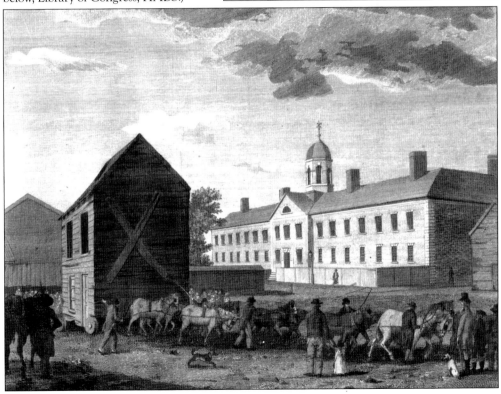

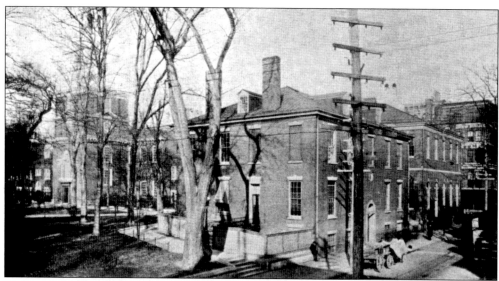

Philosophical Hall (above), home of the American Philosophical Society, has existed on South Fifth Street near Washington Square since 1789. It was erected on a portion of the statehouse yard (now Independence Square) deeded to the society by the Pennsylvania Assembly. The scholarly organization, founded by Benjamin Franklin in 1743, promotes research in the sciences and humanities. Members have included George Washington, Thomas Jefferson, Benjamin Rush, Charles Darwin, Thomas Edison, Louis Pasteur, and Albert Einstein. To expand its library, the society added a windowless third story to Philosophical Hall in 1890 (below in 1947). The addition, derided as "dungeon-like" and disharmonious, proved inadequate for the library, which was relocated. The society removed the offensive addition in 1949. (Independence National Historical Park.)

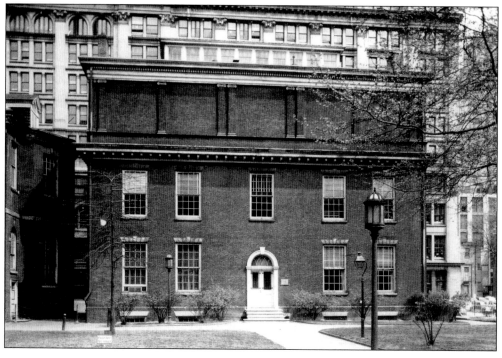

Holy Trinity Roman Catholic Church was erected in 1789 at Sixth and Spruce Streets, just south of Washington Square, by German Catholics. It was the first parish church in the United States to serve a national group. The Catholic population of Philadelphia was then estimated at 8,000. At about the same time the church constructed a school, visible to the west of the church in the 1914 photograph above. In 1797, Holy Trinity established the first Catholic orphan asylum in America to care for children whose parents perished in the city's yellow fever epidemics of the 1790s. Land adjacent to the church was converted to a graveyard in 1801. The church interior, below in 1914, is little changed today. (Above, Holy Trinity Roman Catholic Church; below, Philadelphia Archdiocesan Historical Research Center.)

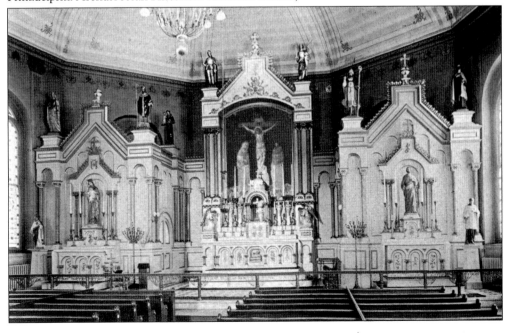

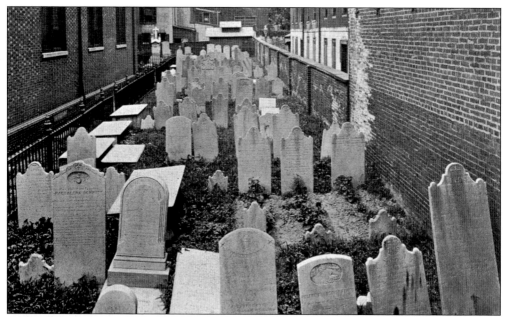

Among those buried in the graveyard of Holy Trinity Church on South Sixth Street are Acadians who settled in Philadelphia after being expelled from Nova Scotia by the British for their loyalty to the French in the French and Indian War. Henry Wadsworth Longfellow's poem about this tragedy, *Evangeline*, refers to the graves of two lovers lying in the little Catholic churchyard in the city. (Holy Trinity Roman Catholic Church.)

Langdon Cheves, president of the Second Bank of the United States, built this dwelling about 1825 at West Washington Square and Locust Street on the site of a livery stable. The house was sketched when it was later owned by Shakespearean scholar Horace Howard Furness. His brother, architect Frank Furness, reportedly renovated the interior in extraordinary fashion. The house was razed in 1912 to build offices for the American Gas Company. (Library of Congress, Prints and Photographs Division.)

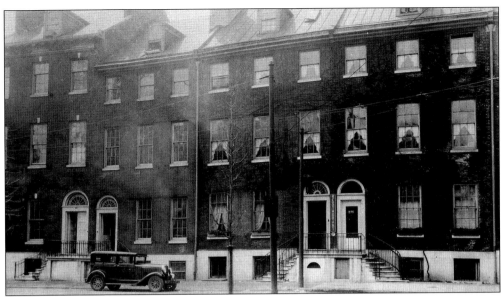

Six houses were built on the south side of Washington Square west of Seventh Street between 1818 and 1823. Four of them are shown above, Nos. 700 to 706. Their exteriors were largely unchanged in this 1932 photograph, although one house appears to have been converted to a restaurant. These Federal-style homes are fine examples of the period. They are brick with marble trim, decorative ironwork, and fanlights set above eight-panel doors. The interiors featured mahogany folding doors and mantelpieces of Pennsylvania gray marble. In 1846, young women attended a French seminary at No. 706 operated by Charles Picot. The living room of this home, restored during the 1960s, is shown below in 1975. Five of these houses remain today. (Above, Philadelphia City Archives, PhillyHistory.org; below, Library of Congress, HABS.)

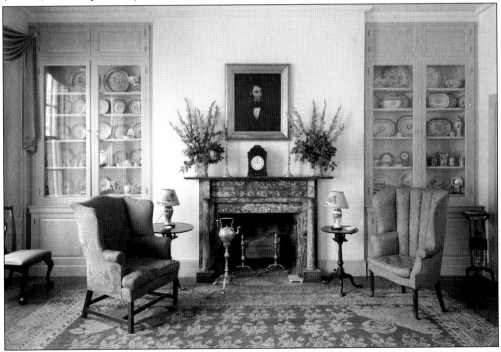

Among the six stylish houses built on the south side of Washington Square west of Seventh Street between 1818 and 1823, No. 700 on the corner (below) was the largest and most lavish. Wider and taller than its neighbors, it is a notable example of Federal architecture with Georgian characteristics. Curving steps of white marble framed by a delicate wrought-iron balustrade (left) lead to the double front door topped by a fanlight. The house boasted cellars for wine and coal. Constructed for merchant Asaph Stone, the house was purchased in 1835 by James Meredith, a prominent attorney, whose name remains associated with it. (Left, Free Library of Philadelphia, Print and Picture Collection; below, Independence National Historical Park.)

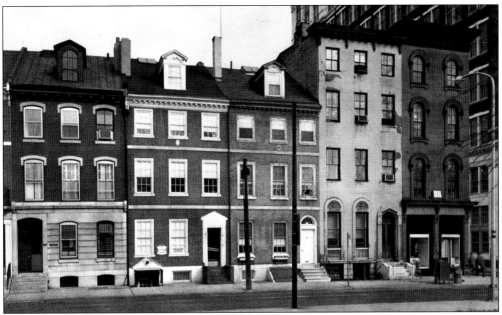

These houses on Walnut Street west of Seventh across from the square's northwest corner may be the first row houses in Philadelphia built on a uniform plan. In 1797, William Sansom acquired Robert Morris's property between Seventh and Eighth Streets at a sheriff's sale. He hired Benjamin Henry Latrobe to design a terrace (row) of houses along the Walnut side. Completed in 1799, the houses rented for $200 a year. The Walnut Street houses became known as Sansom's Row. They have been substantially altered over the years as these photographs indicate. Nos. 707 and 705 (second and third from left above) retain much of their original appearance. (Philadelphia City Archives, PhillyHistory.org.)

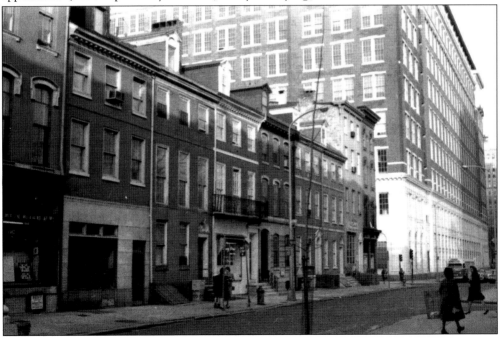

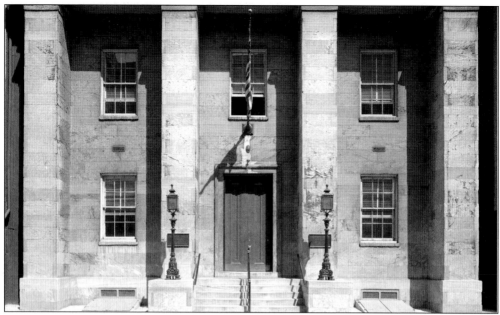

This 1826 classic at 15 South Seventh Street narrowly escaped the wrecker's ball in 1935. It originally housed a school for mechanics (engineers) that evolved into the Franklin Institute, a research and teaching center. After the institute relocated, the city considered razing the building. However, preservationists prevailed upon radio pioneer A. Atwater Kent to purchase it and create a city history museum in 1941. (Library of Congress, HABS.)

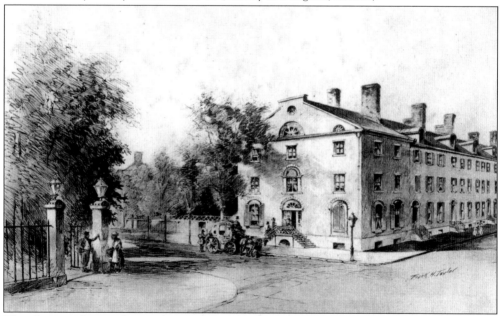

This drawing depicts the northwest corner of Washington Square in the early 19th century. The corner house, which faces the square, was built in 1807 for John Dorsey. It was the first and finest of those homes on the south side of Walnut Street known as York Row. The house was razed in 1867 for construction of the Philadelphia Savings Fund Society building. (Free Library of Philadelphia, Print and Picture Collection.)

A row of red-painted frame tradesmen's houses on the south side of Walnut Street just west of Washington Square was demolished about 1807–1808 to make way for the grander brick structures known as York Row. The builders were Joseph Randall, a carpenter, and Thomas Ridgeway, a bricklayer. The row stretched from the northwest corner of the square at Seventh Street west to Eighth Street. The structure at Seventh and Walnut facing the square was the most distinctive with balustrades and arched windows. The substantial entryway of the house at 714 Walnut Street is shown below. (Right, Historical Society of Pennsylvania; below, Library of Congress, HABS.)

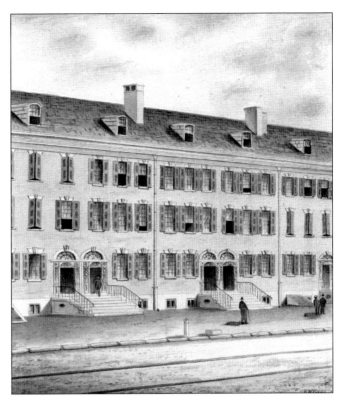

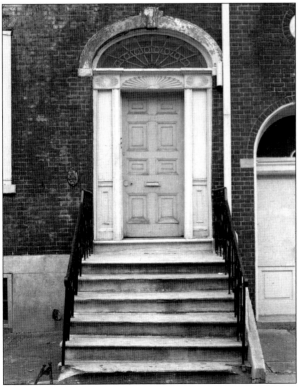

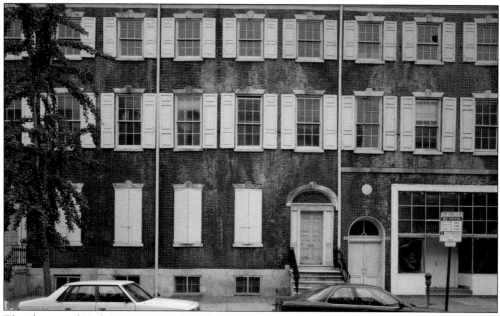

The demise of York Row occurred gradually. The large house at Seventh and Walnut Streets was demolished in 1867 for construction of the Philadelphia Savings Fund Society. Additional York Row houses along Walnut Street fell as the society extended its home office incrementally through the years. The facades of the three buildings above are preserved as part of a recent commercial project. (Library of Congress, Prints and Photographs Division, HABS.)

One of the many nearby establishments where early residents of the Washington Square neighborhood might refresh themselves was the Bell Tavern at 48 South Eighth Street. It was built in 1828, well before this 1859 photograph. Described as a "hole in the wall," the Bell was said to be a popular hangout for politicians. (Free Library of Philadelphia, Print and Picture Collection.)

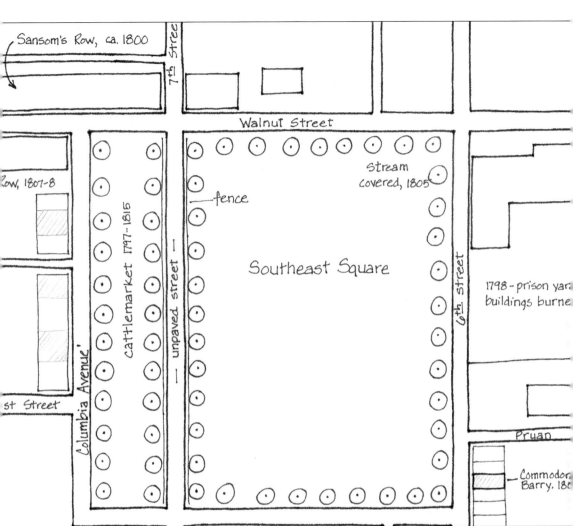

This diagram reveals the substantial changes at Southeast Square after the Revolutionary War. The square remained enclosed by a wooden fence, but rows of poplars had been planted around its borders. The city closed the square as a burial ground in 1795 and opened Seventh Street through the square. This isolated a strip on the western edge that became a cattle market. The two creeks that flowed through the square and merged at Sixth Street were covered and routed into a sewer under the Walnut Street Prison. A debtors' prison (unlabeled) had been built in 1785 near Sixth and Pruan (Locust) Streets on the grounds of the Walnut Street Prison. Prominent residential development included York and Sansom's Rows along Walnut Street and the recently constructed houses on the eastern and western sides of the square. (Independence National Historical Park.)

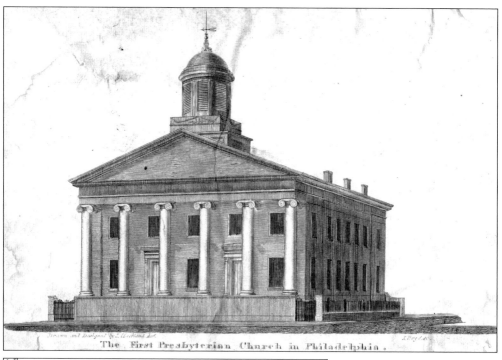

The First Presbyterian Church in Philadelphia.

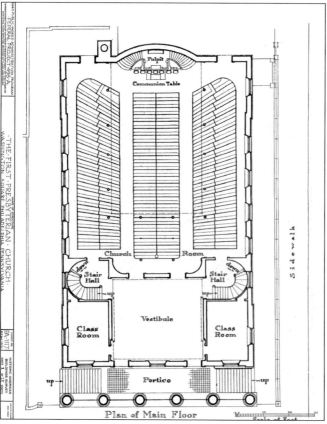

Plan of Main Floor

Construction of First Presbyterian Church in 1822 on the south side of the square enhanced the area's residential attractiveness. Architect John Haviland modeled the structure on an Ionic Greek temple, using brick coated in mortar and painted to resemble marble. As noted in the architectural drawing at left, Haviland's interior featured three blocks of pews with the outer blocks angled toward the center to afford a better view of the pulpit. Before moving to Washington Square, the church had occupied a building with a more elaborate classical facade erected at High (Market) and Bank Streets in 1704. (Library of Congress, HABS.)

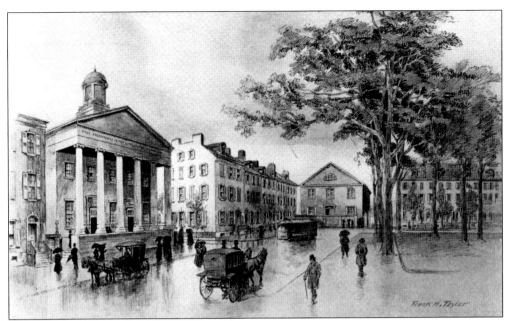

This 1900 sketch by Frank H. Taylor illustrates early development around the square's southwest corner. The neo-Greek First Presbyterian Church of architect John Haviland completed in 1822 looms on the left. To the right of the church, a row of elegant residences built between 1818 and 1823 leads the eye to the Society of Friends' Orange Street Meeting House, built in 1832, facing east at the end of the block. (Free Library of Philadelphia, Print and Picture Collection.)

The oldest working theater in America at Ninth and Walnut Streets, west of the square, celebrated its 200th anniversary in 2009. The Walnut Street Theater opened in 1809 as the New Circus, featuring a towering dome, a dirt floor for animal acts, and a troupe of actors. After structural changes, it became a playhouse in the 1820s. Many noted actors have trod the Walnut's venerable boards. (Library of Congress, HABS.)

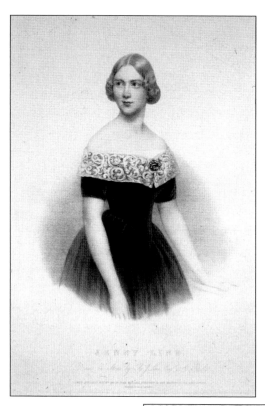

Jenny Lind, "the Swedish Nightingale," performed at Musical Fund Hall, 808 Locust Street, in 1850 and 1851. Lind sang on stage at age 10 and by 17 was a favorite in the Royal Swedish Opera. After gaining renown throughout Europe, she was invited to America by P. T. Barnum in 1850 where she gave 93 concerts. (Library of Congress, Prints and Photographs Division.)

One of America's earliest recital halls stands today, substantially altered, a block west of Washington Square at 808 Locust Street. Musical Fund Hall was erected in 1824 by the Musical Fund Society for "the relief of decayed musicians and their families," among other purposes. The hall was the city's primary concert space until the Academy of Music opened on Broad Street in 1857. (Library of Congress, Prints and Photographs Division.)

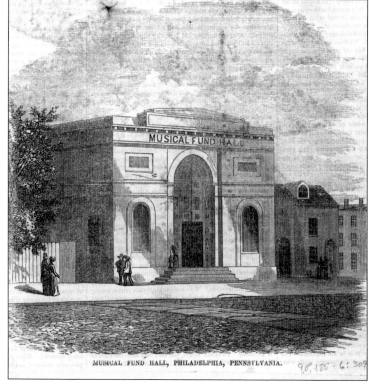

MUSICAL FUND HALL, PHILADELPHIA, PENNSYLVANIA.

Musical Fund Hall was enlarged in 1847 and remodeled in 1891. In 1856, it hosted the first Republican national convention that nominated James C. Fremont for president. The building later fell on hard times (seen here in 1976). It was purchased by the city in 1964 and by 1981 converted to condominiums. However, these changes led to revocation of the hall's national historic landmark designation. (Library of Congress, Prints and Photographs Division, HABS.)

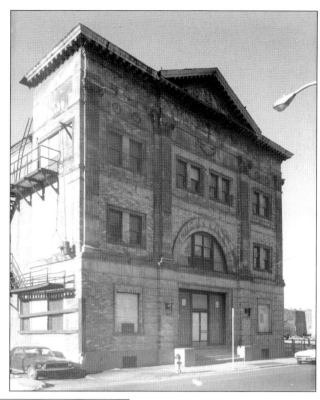

Southeast Square was laid out as a park in 1817 and a veritable arboretum of familiar and exotic trees planted along formal concentric walks. However, the public would have to wait. The square remained enclosed by a white paling fence and not generally accessible. In 1825, it was formally renamed Washington Square and shortly thereafter opened as a public promenade. This etching celebrated the event. (The Library Company of Philadelphia.)

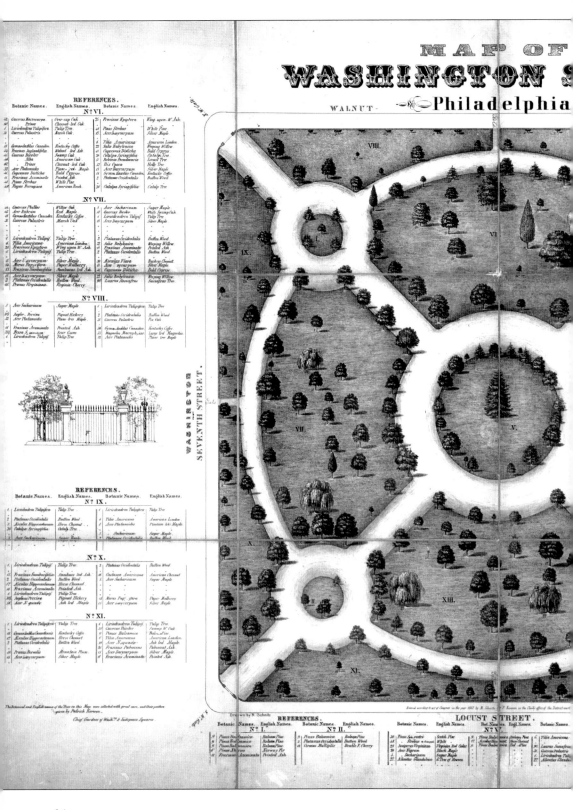

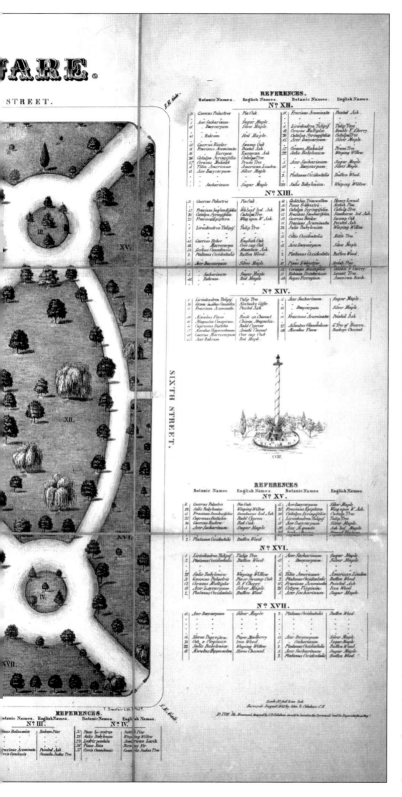

Southeast Square was closed as a burial ground in 1795, and trees and walks were added. Residential growth spurred proposals for additional improvements. In 1815, the city closed the cattle market west of Seventh Street, which then ran through the square. A year later, plans to develop the square as a park took shape. The square was laid out as a formal park in 1816–1817 by George Bridport, an English-born decorative painter. Two hundred trees representing 50 varieties, native and European, were planted amid the circular walkways. Andrew Gillespie, a commercial gardener, supervised their planting. The resulting urban arboretum won high praise for its beauty and variety. This 1842 map by John B. Colahan identifies each tree and depicts the square's 1837 iron palisade fence. (The Historical Society of Pennsylvania.)

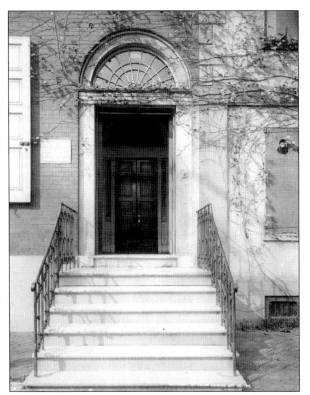

The three houses below are all that remain of the private residences that once lined the west side of the Washington Square. They were built on speculation between 1818 and 1823 by merchant John Lisle. Intended for the upper-middle-class buyers who were drawn to the square at the time, they are 27 feet wide and three and a half stories with fanlights and decorative ironwork similar to the homes on the south side of the square. The quality of construction is evident in the detail of the entry to No. 224 shown in the *c.* 1911 photograph at left. This house was purchased in 1832 by John Morin Scott, later mayor of the city. His lavish refurbishments included a bathtub hewn from a solid block of marble. (Left, Temple University Libraries, Special Collections.)

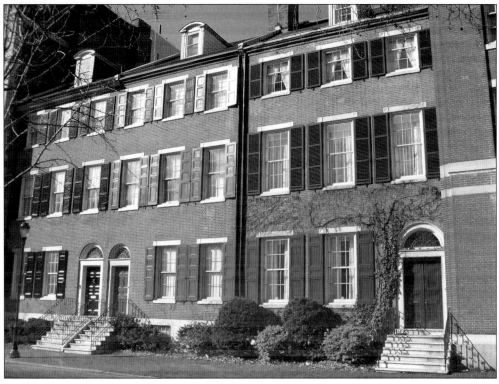

Two

A NEIGHBORHOOD
TAKES ROOT
1831–1900

Washington Square's rustic charm continued to attract residential development as well as professional and institutional interest. The Society of Friends erected a meetinghouse at the southwest corner of the square in 1832 on land purchased from the Penn family in 1774. Gaslights were installed in the square in 1837 and an iron palisade fence erected. The same year, the Walnut Street Prison was demolished. Houses, later known as Lawyers' Row, were erected on the prison site along Sixth Street between Walnut and Adelphi Streets. South of Adelphi Street, John Notman designed a classic Italianate building for the Athenaeum of Philadelphia, a subscription library, completed in 1847.

In 1853, the Pennsylvania Bible Society erected a building at 701 Walnut Street, on the site of a Sansom's Row property. The society continues to distribute Bibles from the four-story brownstone to this day. The Philadelphia Savings Fund Society constructed its Italianate Palladian–style headquarters in 1868 on the square's northwest corner on the site of a grand town house built some 60 years earlier. The society, founded in 1808, was the nation's first mutual savings bank where the depositors were also owners.

The Philadelphia Fountain Society selected Washington Square as the site of its first fountain in 1869. The society's objectives were to relieve animal suffering and promote temperance. Philadelphia's municipal bureaucracy had outgrown its space in Independence Square by 1869. The city rashly proposed razing the structures there to construct new offices. Angry citizens forced a referendum to decide whether the proposed buildings should be placed either in Washington Square or in more central Penn Square. Penn Square won decisively, allowing Washington Square to remain an open space.

The city's residential development moved ever westward, spurred by the advent of the horse-drawn trolley in 1858. Offices and businesses replaced families in the Washington Square neighborhood. The park had grown rather dowdy by 1882, when the city gave it a face-lift. An angular grid of flagstone walks replaced concentric gravel pathways. Some trees were removed, and a granite border supplanted the iron fence. In 1898, a monument to the Washington Grays artillery unit was placed at the center.

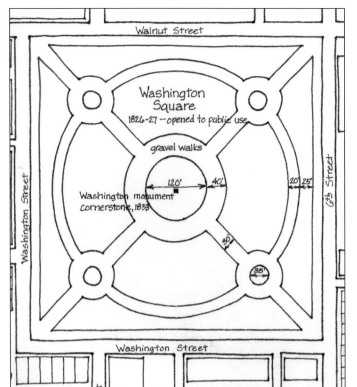

By 1833, Southeast Square, renamed Washington Square in 1825, had become a public promenade. Its circular gravel walks were set amid an arboretum of trees. The square's integrity was restored in 1822 when the incursion of Seventh Street through the park was eliminated. A cornerstone for a Washington monument was laid in the center in 1833 with much fanfare. But subscriptions fell short and a statue was never erected. (Independence National Historical Park.)

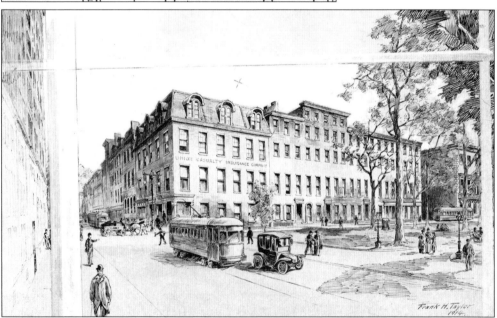

In 1836, John Moss purchased the old Walnut Street Prison on the southeast corner of Sixth and Walnut Streets for about $300,000 and demolished its buildings. When plans for a luxury hotel fell through, he sold the property as lots. The resulting Sixth Street houses in this Frank Taylor lithograph became known as Lawyers' Row. They were leveled in 1913 to construct the Penn Mutual building. (Temple University Libraries, Urban Archives.)

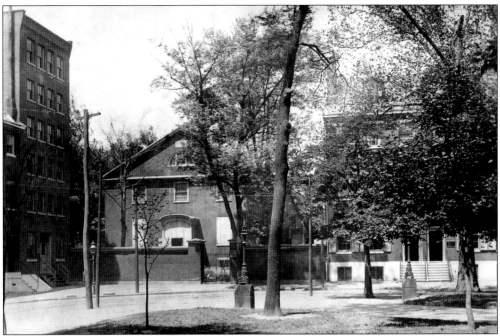

The Orange Street Friends Meeting House was constructed in 1832 on the west side of the square on land the Society of Friends had purchased from the Penn family as a burial ground in 1774. It was named for its southern boundary, a narrow street between Seventh and Eighth Streets, now Manning Street. Although a high water table precluded burials, the Friends profited by selling building lots. An undated photograph of the meetinghouse above shows the building on the left, presently occupied by Bisel law publishers. The sketch below depicts the house that it replaced. (Friends Historical Library of Swarthmore College.)

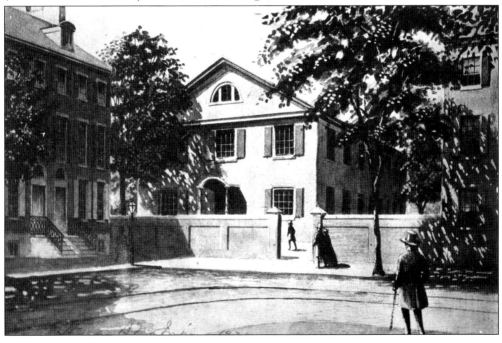

Friends attend a service at the Orange Street Meeting House in this 1900 photograph. The meeting had five ministers, and First Day morning attendance was said to average 75. The meetinghouse was sold in 1908 to the Farm Journal, which demolished it to build its headquarters at the southwest corner of the square in 1912. (Friends Historical Library of Swarthmore College.)

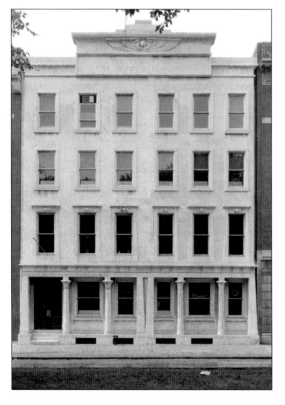

Architect John Haviland designed this building for the Pennsylvania Fire Insurance Company at 508–510 Walnut Street in 1838. He selected Egyptian Revival, a style that enjoyed popularity following Napoleon Bonaparte's invasion of Egypt. It employed Egyptian motifs, including lotus capitals and bundled papyrus columns. The building's facade was attached to the 22-floor Penn Mutual Insurance Company tower built on the site in 1975. (Library of Congress, Prints and Photographs Division, HABS.)

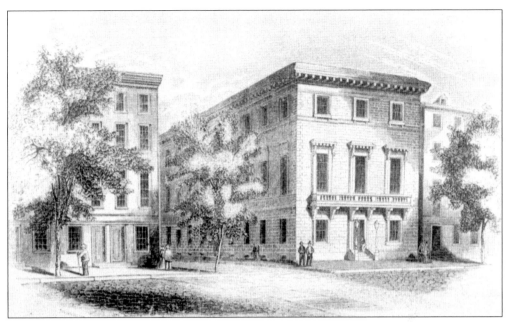

The Athenaeum of Philadelphia has graced the east side of Washington Square at 219 South Sixth Street since 1847. John Notman, a young Scot architect, won his commission in a spirited competition sponsored by the subscription library. On part of the former Walnut Street Prison site, Notman produced a classic structure in the form of an Italian Renaissance palazzo. The 1854 engraving above appeared in *Gleason's Pictorial Drawing Room Companion*. Plain and deceptively compact on the outside, the structure contains a stately staircase, lit by a lantern in the roof, leading to a richly ornamented reading room (right). Considered one of the significant American structures of the 19th century, the building is a national historic landmark. (Philadelphia City Archives, PhillyHistory.org.)

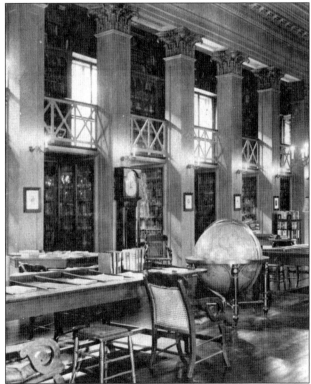

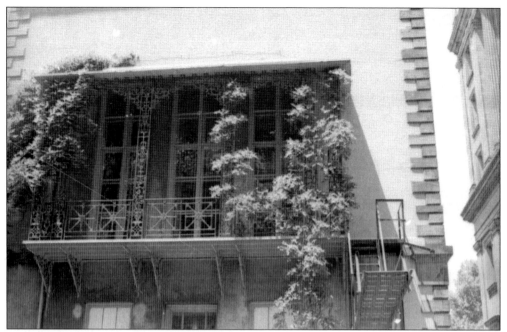

The rear of the Athenaeum of Philadelphia looked eastward toward the Delaware River over an enclosed, landscaped garden. Members of the library might enjoy this view from what was described as the "Trafalgar" balcony pictured in this 20th-century photograph. (Philadelphia City Archives, PhillyHistory.org.)

The Athenaeum of Philadelphia has endured for over 160 years on Washington Square. But a more mundane, if once necessary, adjunct designed by the building's architect John Notman did not fare as well. A brick privy erected in the building's garden in 1847 was destroyed in 1962 when an old buttonwood tree fell on it in a storm. The facility boasted six private compartments, each with exterior access and a slatted door. (Library of Congress, HABS.)

This decorative balustrade on a residence at 628 South Washington Square is illustrative of the artistic ironwork, often by the Yellin Ironworks, that adorned residences on the square during the 19th century. The house was later demolished, as was the First Presbyterian Church (columns on left). The Farm Journal building is visible at center. (Free Library of Philadelphia, Print and Picture Collection.)

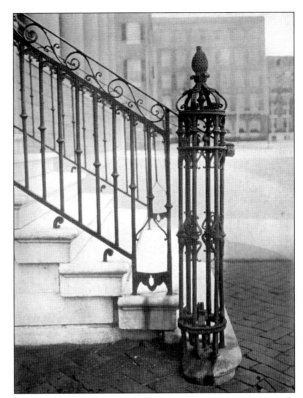

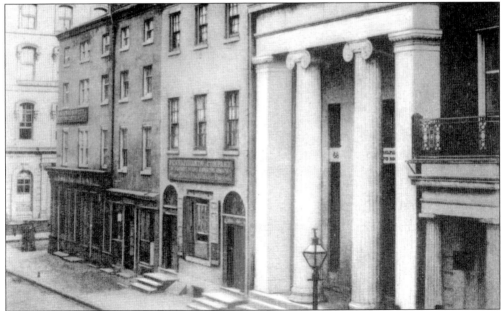

The Philadelphia Savings Fund Society moved to its Washington Square office in 1868 from an elegant marble Greek Revival building still standing at 306 Walnut Street. The building with its two-story portico supported by Ionic columns was designed in 1840 by Thomas Ustick Walter, architect of the Capitol dome in Washington. This photograph was taken around 1860. (Library of Congress, Prints and Photographs Division, HABS.)

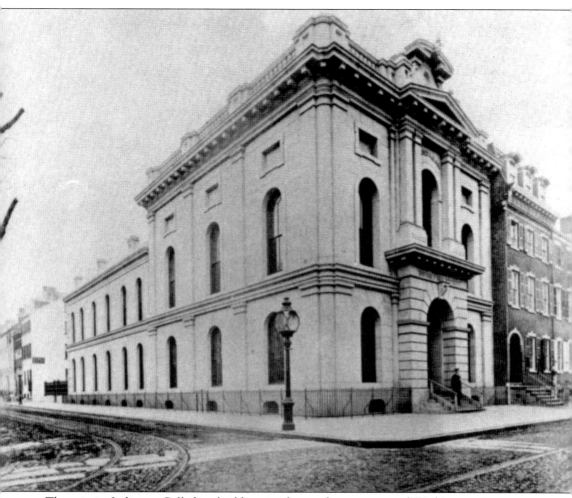

The granite Italianate Palladian building on the northwest corner of Washington Square was constructed in 1868 for the Philadelphia Savings Fund Society. Once fashionable residences on the west side of the square and west along Walnut Street fell during the process. The society, which became popular with Philadelphia residents following its founding in 1816, was a mutual savings (or "people's") bank owned by its depositors rather than stockholders. The building was designed by architects Samuel Sloan and Addison Hutton with several later additions. In 1932, the society moved its headquarters uptown to a modern classic 36-story tower at Twelfth and Market Streets. The facade of its Washington Square building has been retained as part of a commercial development in the 700 block of Walnut Street. (Free Library of Philadelphia, Print and Picture Collection.)

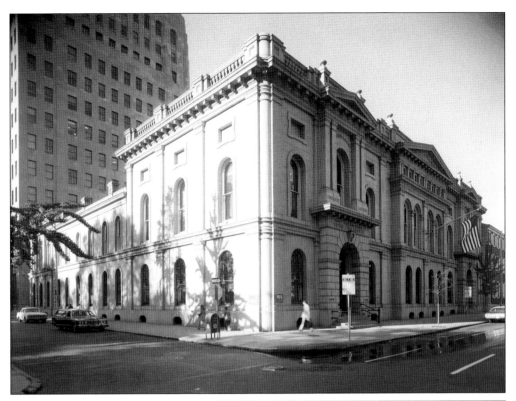

As the Philadelphia Savings Fund Society grew, it expanded its 1868 home office at Walnut Streets and West Washington Square (above). Addison Hutton, one of the original architects, extended the building to the rear in 1886 and westward along Walnut Street in 1888. In 1898, Furness, Evans and Company virtually duplicated the original building farther west along Walnut Street. The architects strove to convey an illusion of unity, ultimately connecting two sprawling pavilions with an arcade. Uniform design elements, such as the arched windows and decorative ironwork (right), helped to tie the sections together. (Library of Congress, Prints and Photographs Division, HABS.)

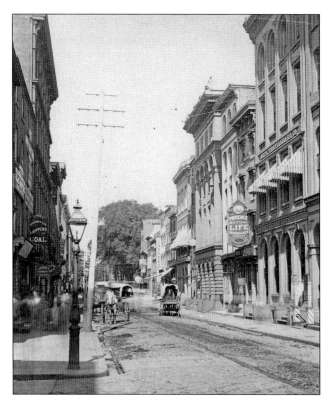

Two-way traffic flows along Walnut Street in this *c.* 1870 photograph looking west from Fourth Street. Businesses, including the Phoenix Mutual Life Insurance Company and Spofford and Clark Shippers of Coal, line the street. Note the horse-drawn streetcar and the street sign incorporated in the lamp for night visibility. The foliage of Independence Square appears ahead. (Free Library of Philadelphia, Print and Picture Collection.)

During the 19th century, Walnut Street from Washington Square east to Dock Street was the city's "insurance district." Insurance companies and agencies lined these blocks and spilled into the cross streets. This *c.* 1875 photograph depicts the modest early headquarters of the Insurance Company of North America at 232 Walnut Street. The company was growing, however, and would purchase the larger building on the left in 1880. (ACE Group Archives.)

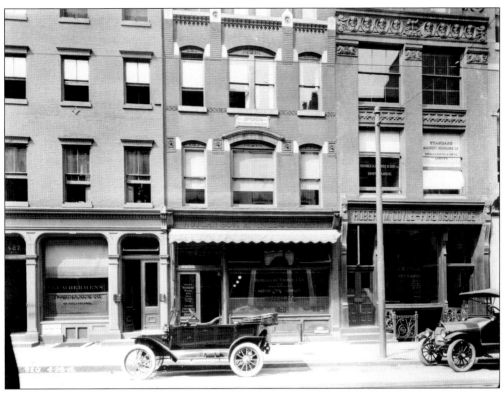

Through the years, insurance companies have maintained a presence in the blocks of Walnut Street east of Washington Square. For example, the Jefferson Fire Insurance Company, organized in 1855, built its office at 425 Walnut Street in 1885. It is shown (above, center) in 1915, inconspicuously marked by a placard over the second-floor window. In 1936, Aetna Insurance Company purchased and renovated the building (right). Aetna relocated to offices in the Public Ledger Building at Sixth and Chestnut Streets in 1948. The old Jefferson building at 425 Walnut Street was demolished in 1959 as part of the Independence Mall clearance project. (Above, Library of Congress, HABS; right, ACE Group Archives.)

Bible House at 701 Walnut Street, the brownstone at left, has been a distribution center for Bibles since its construction in 1853. Before acquiring this property, the Philadelphia Bible Society was located on Chestnut Street between Sixth and Seventh Streets. The society was organized in 1808 to publish and distribute Bibles at an affordable price. In 1840, the society, later the Pennsylvania Bible Society, stopped printing Bibles to focus solely on their distribution. "Bibles in 100 languages" were offered at the society pavilion at the 1876 Centennial Exposition. Below, society workers prepare Bibles for distribution. (Pennsylvania Bible Society.)

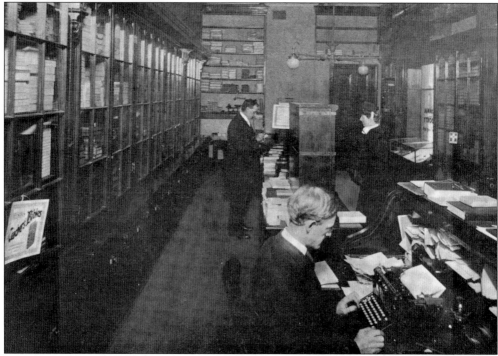

Merchant Robert Ralston founded the Philadelphia Bible Society in 1808. Born in Little Brandywine in 1761, he amassed a fortune in the East Indian trade. Ralston spent liberally on benevolent causes. He contributed to the establishment of a widows' and orphans' asylum and the Mariners Church in Philadelphia. In 1819, he became the first president of the Presbyterian Church Board of Education. (Pennsylvania Bible Society.)

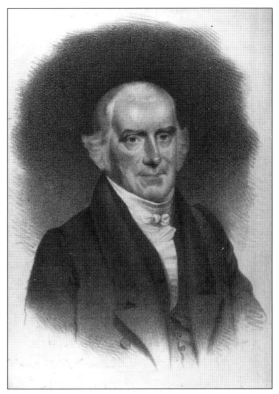

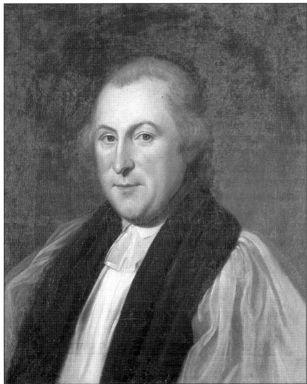

Bishop William White was president of the Pennsylvania Bible Society from 1808 until 1836. The prominent cleric was instrumental in establishing the American Episcopal Church independent of the Church of England. He was an advocate of liberty and religious freedom and rector of Philadelphia's Christ Church. His house at 309 Walnut Street has been restored by the National Park Service. (Independence National Historical Park.)

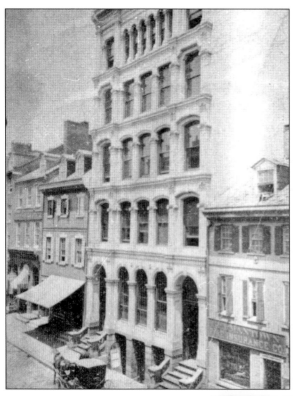

Bishop William White, a religious leader and key figure in the nation's struggle for independence, erected a house at 309 Walnut Street in 1787. The Federal-style dwelling (left with awning, around 1875) was one of the few then with an indoor toilet. Bishop White was rector of Christ Church and St. Peter's Church, in addition to heading the Pennsylvania Bible Society. He served as chaplain to the Continental Congress and, later, the United States Senate. Bishop White lived here with his family until his death in 1836. The structure was subsequently altered and used commercially until being acquired by the National Park Service and restored between 1964 and 1966 (below). The refurnished house may be visited by reservation. (Independence National Historical Park.)

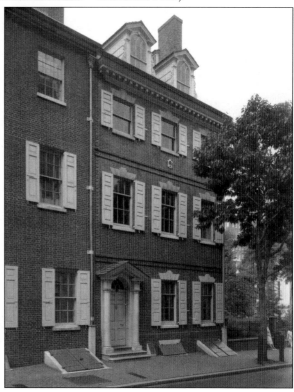

The Philadelphia Fountain Society selected Washington Square as the site of its first fountain in 1869. The c. 1870 photograph (right) depicts the ornate granite fountain on the north side of the square at Walnut and Seventh Streets. Water flowed from the pedestrian fountain facing the square to horse and dog troughs on the street side. Commerce in the city relied on horse-drawn vehicles but few public sources of drinking water existed. The society would erect more than 70 fountains throughout the city. These fell into disuse with the advance of motorized streetcars and trucks. This fountain was relocated to the south side of Washington Square in 1916, where it continues to function sans its decorative tablet, globe, and eagle (below). (Right, the Library Company of Philadelphia; below, Independence National Historical Park.)

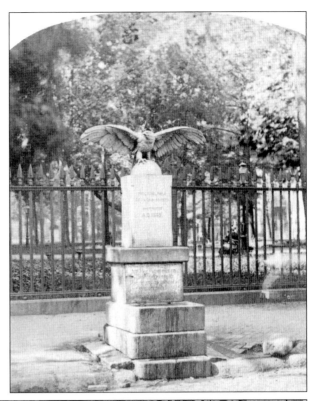

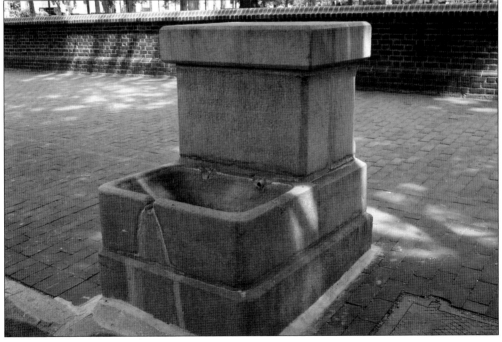

Dr. Wilson Cary Swann, founder of the Philadelphia Fountain Society, was a wealthy patron of the arts and social reformer. Few public sources of drinking water for humans or animals existed in mid-19th century Philadelphia. Taverns offered water for thirsty horses but expected their drivers, in turn, to buy a drink. By making fresh, free water amply available, Dr. Swann hoped both to promote temperance and relieve animal suffering. (Union League of Philadelphia, Abraham Lincoln Foundation.)

By the latter half of the 19th century, horse-drawn streetcars plied streets on three sides of Washington Square. Although the city's transportation and commerce depended on horsepower, these animals were expendable and perished frequently from heat exhaustion, thirst, and abuse. The Philadelphia Fountain Society sought to relieve their suffering by erecting more than 70 horse trough fountains throughout the city. (Free Library of Philadelphia, Print and Picture Collection.)

The Public Ledger erected the building below on the southwest corner of Sixth and Chestnut Streets in 1867. Established in 1836, the *Ledger* was Philadelphia's first penny newspaper and in its day the most popular in the city. The newspaper flourished after George W. Childs (right) purchased it with Anthony J. Drexel in 1864. Childs revamped the paper to make it one of the country's most influential journals. In 1913, magazine magnate Cyrus Curtis purchased the *Public Ledger* from *New York Times* publisher Adolph Ochs. Curtis determined the newspaper needed more space and erected a larger building on the site in 1924. (Right, Library of Congress, Prints and Photographs Division; below, Free Library of Philadelphia, Print and Picture Collection.)

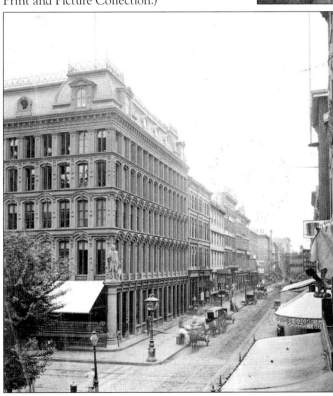

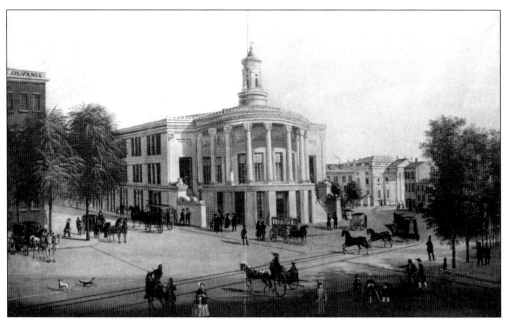

The Merchants' Exchange was completed in 1834 as both a stock and merchandise exchange. Architect William Strickland designed the building at Third and Walnut Streets with a distinctly split persona. Its rectangular main structure along Third is Greek Revival, a style familiar at the time. But the building's rear consists of a sweeping semicircular portico framed by Corinthian columns facing toward the Delaware River. (Library of Congress, HABS.)

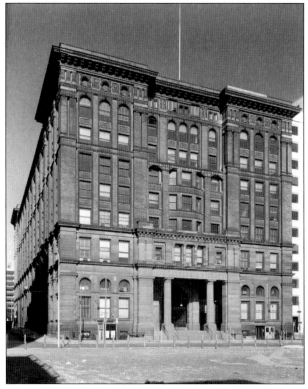

The Philadelphia Bourse at 11 South Fifth Street, completed in 1895 near Washington Square, housed a stock exchange, maritime exchange, and grain-trading center. The Victorian building, by G. W. and W. D. Hewitt, was one of the earliest with a steel frame. Its six-story atrium, originally the trading floor, was surrounded by office tiers. The bourse was converted to a shopping and office complex in 1982. (Library of Congress, HABS.)

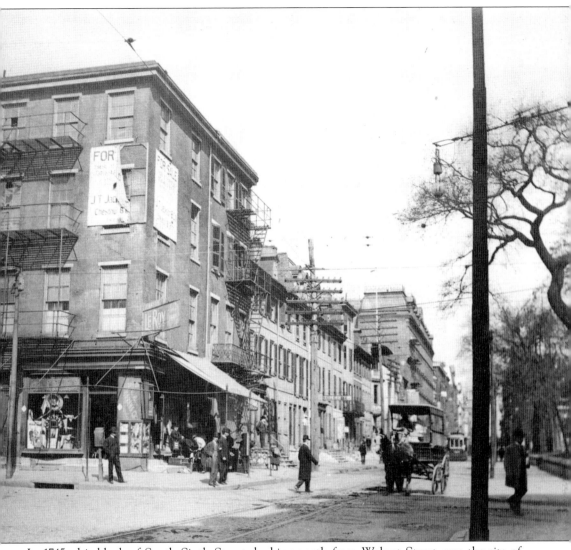

In 1745, this block of South Sixth Street, looking north from Walnut Street, was the site of James Logan's library, one of the first buildings constructed along Washington Square. The commercial structure sporting a "for sale" sign and the row of residences later erected in this block look somewhat the worse for wear in this 1902 photograph. They would be demolished eight years later to make way for the Curtis Publishing Company building. The area's falling property values proved a boon to companies like Curtis looking to expand operations in the city. Although electric streetcars debuted in 1892, horse-drawn wagons still made most deliveries in the city. Note the 1867 Public Ledger building with mansard roof to the north on Sixth Street. (Free Library of Philadelphia, Print and Picture Collection.)

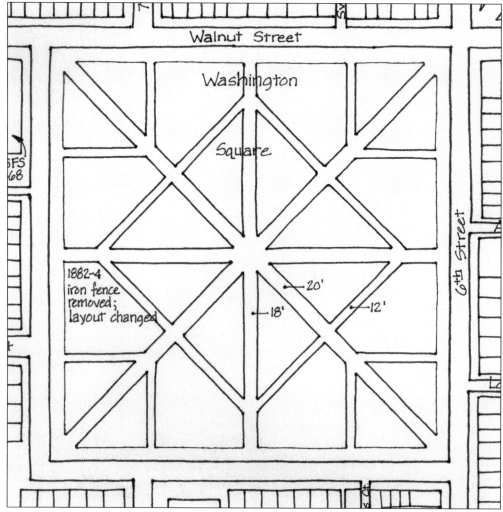

Between 1882 and 1884, the city decided to make Washington Square more "attractive as a pleasure ground and . . . as a thoroughfare." The square was opened to full public view. The iron palisade fence that had surrounded the square since 1837 was removed and replaced with a six-inch granite edging. The 1816 circular gravel walks were replaced by a busy geometric web of flagstone-covered walks bisecting the square diagonally, as shown in 1885. Accessibility was increased with multiple entrances at each corner and on the sides. The changes, reflective of those made earlier in Independence Square, expedited pedestrian traffic through the square. Benches were placed around the center. Fresh sod was laid and several trees were removed to accommodate the new design. (Independence National Historical Park.)

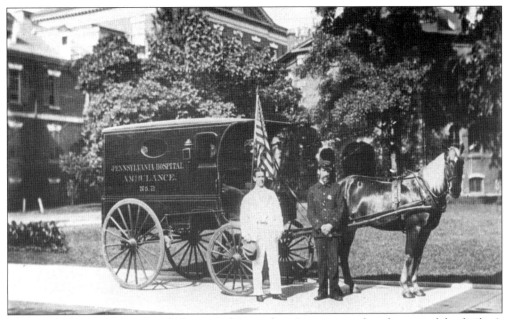

The Pennsylvania Hospital ambulance and "attendants" are pictured at the rear of the facility's Pine Building in the summer of 1898. The ambulance service was initiated in 1876. The horse-drawn coaches were replaced by motorized vehicles in 1912. The hospital, two blocks south of Washington Square, was founded in 1751 by Benjamin Franklin and Dr. Thomas Bond. (Pennsylvania Hospital Archives.)

Long before the memorial to the unknown soldier of the Revolution was installed in Washington Square in 1957, the war's fallen heroes were recognized by this simple plaque. It memorializes "the many American soldiers, who during the war for independence . . . were buried in this ground." It was erected by the Quaker City Chapter, Daughters of the American Revolution in 1900 in the square's northeast quadrant. (Temple University Libraries, Urban Archives.)

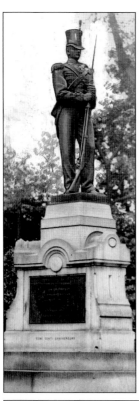

A monument was placed in the center of Washington Square in 1898 to commemorate the Washington Grays artillery unit for its Civil War service. The unit of the 17th Pennsylvania volunteer regiment had mustered on the west side of the square. This splendidly arrayed soldier was placed atop the monument and dedicated 10 years later. Today the erect trooper maintains his vigil at the Union League on South Broad Street. (Temple University Libraries, Urban Archives.)

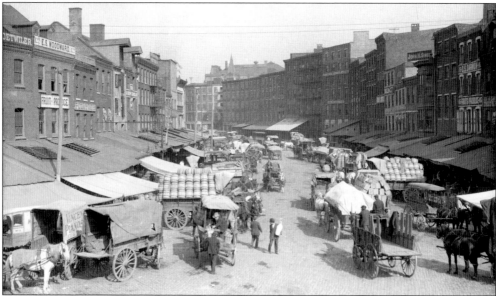

Numerous creeks flowed through Colonial Philadelphia. Two merged at Washington Square to form a stream that fed Dock Creek to the east. When Dock Creek became infamously polluted, the city covered it to form Dock Street. An outdoor produce market eventually grew along the wide street, and in the 19th century, it became the city's wholesale food distribution center, seen above in 1908. It was relocated in 1959. (Library of Congress, Prints and Photographs Division.)

Three

PUBLISHERS PREVAIL
1901–1932

The dawn of the 20th century found Washington Square and its neighbor, Independence Square, in seedy condition. Municipal government's move from Independence Square to the new Philadelphia City Hall left some buildings in the area empty and neglected. An economic recession increased unemployment and homelessness. "Bums and drunks," according to one newspaper, annoyed strollers in the squares. Diminished real estate values may partly explain why Washington Square became the hub of a formidable publishing industry. Other factors may have included the nearby post office, the good light afforded by the open square, or the proximity of kindred enterprises. In any event, publishers and related businesses flocked to Washington Square during the early 20th century.

Earlier arrivals had included the American Bible Society, at Sixth and Walnut Streets in 1853; the Philadelphia Public Ledger, a daily newspaper located at Sixth and Chestnut Streets in 1867; and the Central News Company, a periodicals distributor, at 614 South Washington Square in 1886. J. B. Lippincott Company, a major trade publisher, moved into a new building at 227–229 South Sixth Street in 1901. Lippincott's arrival on the square seemed to stimulate interest among other publishers. In 1904, David McKay moved his book-publishing business to 610 South Washington Square. In 1912, the Farm Journal, the country's leading agricultural magazine, moved into a Colonial-style headquarters erected on the site of the old Orange Street Friends Meeting on West Washington Square.

In 1910, magazine colossus Curtis Publishing began a massive structure that would eventually fill the entire block of Walnut Street between Sixth and Seventh Streets. W. B. Saunders, a leading medical publisher, completed a seven-story building at West Washington Square and Locust Street in 1912. The building boom continued when venerable publisher Lea and Febiger, whose initial backers included the Marquis de Lafayette, constructed an Italianate-style headquarters at South Washington Square and Sixth Street in 1923. But recognition for the most striking new building was earned not by a publisher but by advertising pioneer N. W. Ayer and Sons. In 1929, the nation's oldest advertising agency erected an opulently adorned art deco tower between the Philadelphia Savings Fund Society and W. B. Saunders buildings on the square's west side.

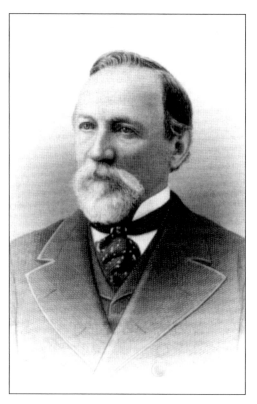

Joshua B. Lippincott founded a publishing house in Philadelphia in 1836. After initially selling Bibles and other religious works, the company expanded into trade books, which became the major part of its business. Through growth and acquisitions, Lippincott became one of the country's largest publishers. Its catalog included novels and reference works in addition to histories, textbooks, and medical books. In 1861, Lippincott moved the company into a building at 715–717 Market Street (below). The first two floors housed a retail store selling books and stationery. Books were bound on the three upper floors. Ten years later the company built an extension, allowing its books to be printed, bound, and distributed under one roof.

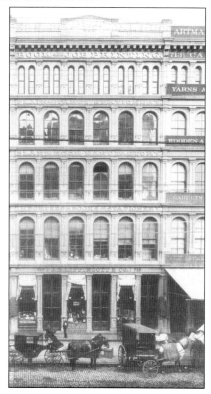

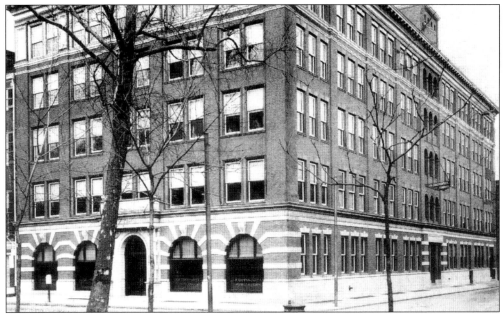

J. B. Lippincott publishers moved to Washington Square in 1901 after fire destroyed its Market Street facility. Its new building (above) on the east side of the square at Sixth and Locust Streets was a self-contained plant for all company publications. The five-story structure, with its distinctive striped front, was designed by William G. Pritchett in Renaissance Revival style. Its construction cost was about $158,000. Lippincott's linotype department is shown below. The company was sold to Harper and Row in 1978. In 1990, it was acquired by Wolters Kluwer and eventually merged with another of that company's businesses to form Lippincott Williams and Wilkins, now located in the Penn Mutual building east of the square. Lippincott's former headquarters on the square has been converted to condominiums.

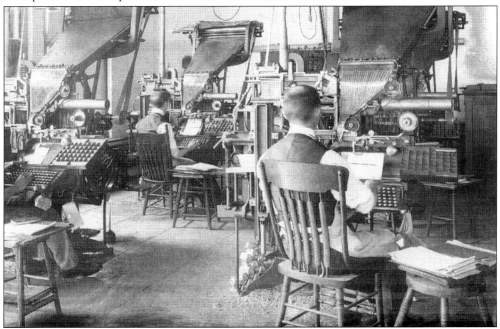

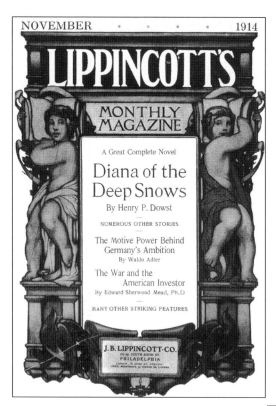

J. B. Lippincott initiated *Lippincott's Monthly Magazine* in 1868. Each issue contained a complete novel along with articles, short stories, and humor. Featured writers included Rudyard Kipling, Jack London, Arthur Conan Doyle, and Oscar Wilde. The magazine described its contents as "fresh, clever, original and clean." Now a collector's item, the literary magazine was published until 1914.

By mid-19th century a substantial portion of Lippincott's sales consisted of multivolume sets of "standard authors," including William Prescott, William Thackeray, Charles Dickens, and Charles Lamb, and reference works. One of the most successful was *Chambers' Encyclopedia of Universal Knowledge.* Joshua Lippincott understood that a reference work needed to look authoritative. Many were lavishly bound and engraved to appeal to a growing middle class.

Three generations of Lippincotts pause at the entrance of J. B. Lippincott's Washington Square headquarters in 1938. They are (from right to left) J. Bertram Lippincott, his son Joseph Wharton Lippincott, and his son Joseph Wharton Lippincott Jr. The three men served in succession as president of J. B. Lippincott. Their collective service spanned 102 years.

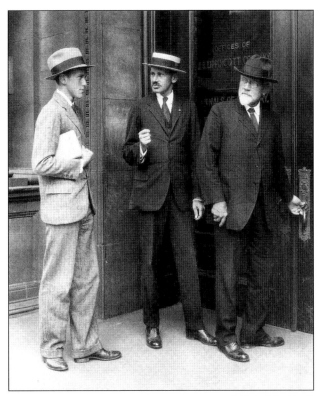

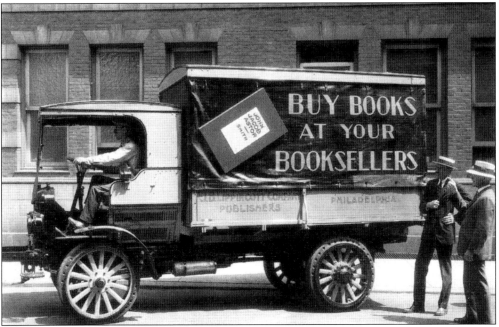

Joseph W. Lippincott continued his family's control of the publisher when he became president in 1926. In 1929, he served a term as president of the National Association of Book Publishers. He is shown above in 1930 with his successor as association president next to a J. B. Lippincott delivery truck bearing a message promoting local bookstores.

A French émigré, one Madame Felicite Virginie Pointe, operated a pension at 239 South Sixth Street in the 1840s. Yielding to more current needs, this house and its neighbor at 241 South Sixth Street were demolished in 1910 for the construction of a firehouse (left). The bright red Georgian structure may have improved public safety but it was yet another indication of the square's decline as a residential neighborhood. The sleek fire horses of Engine 32's early days (below) soon gave way to motorized apparatus, which the Philadelphia Fire Department began to use in 1912. The firehouse remained on the square until 1964 when it was demolished for a parking lot. (Philadelphia City Archives, PhillyHistory.org.)

Cyrus H. K. Curtis published newspapers in his hometown, Portland, Maine, and later in Boston. But upon moving to Philadelphia, Curtis became a leading magazine publisher. He began with the *Tribune and Farmer* in 1890. A column in that publication, edited by his wife Louisa Knapp, evolved into the hugely successful *Ladies Home Journal.* In 1897, Curtis purchased the moribund *Saturday Evening Post* for $1,000. Following his inspired choice of George Horace Lorimer as editor, the Post became another success story. Millions of readers across America subscribed to Curtis magazines, which later included *Holiday, Country Gentleman,* and *Jack and Jill.* Thus when the company began laying the foundation for its new headquarters on the north side of Washington Square in 1910 (below), it could well afford the building's reported $3 million cost. (Right, Free Library of Philadelphia, Print and Picture Collection; below, Independence National Historical Park.)

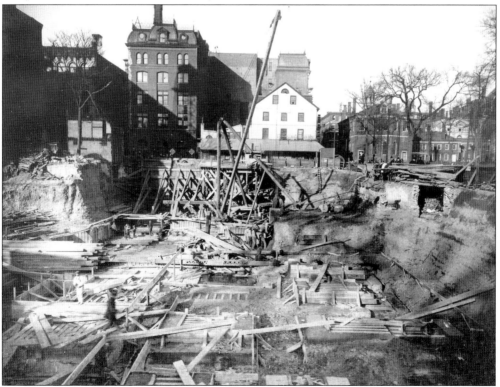

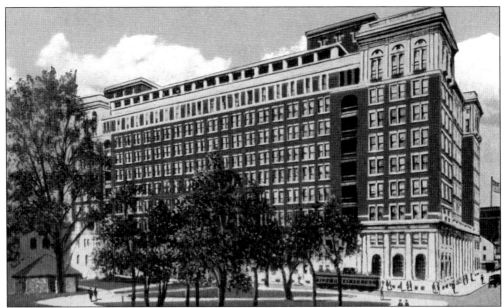

Cyrus H. K. Curtis hired architect Edgar V. Seeler to design his building. Seeler's massive 10-story building in the Beaux-Arts style would be constructed in stages, eventually filling the entire block of Walnut between Sixth and Seventh Streets on the north side of Washington Square. The publication unit with its entrance on Sixth Street facing Independence Square behind 14 imposing Vermont marble columns was completed in 1912. A number of historic houses, depicted in the drawing below, were demolished, some dating from the late 18th century. That is when John Swanwick, a merchant and real estate speculator, purchased much of the Walnut Street block and sold it off as building lots. More recently houses on that block had shared the sobriquet Lawyers' Row with those on Sixth Street south of Walnut. (Free Library of Philadelphia, Print and Picture Collection.)

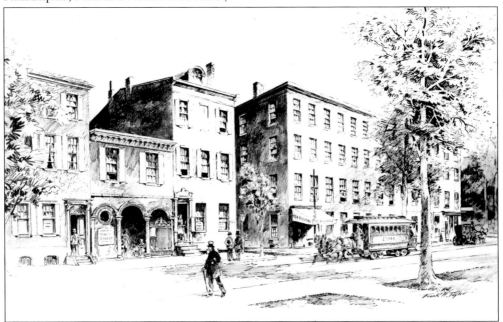

Cyrus H. K. Curtis and his wife are pictured in 1927 on their yacht *Lydonia*, anchored in the Potomac River, after hosting Pres. Calvin Coolidge and the first lady at lunch. The former Kate Stanwood Cutter Pillsbury seen here was the second wife of Curtis. His first wife, Louisa Knapp, originator of the *Ladies Home Journal*, died in 1910. (Library of Congress, Prints and Photographs Division.)

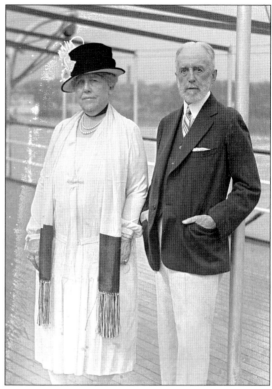

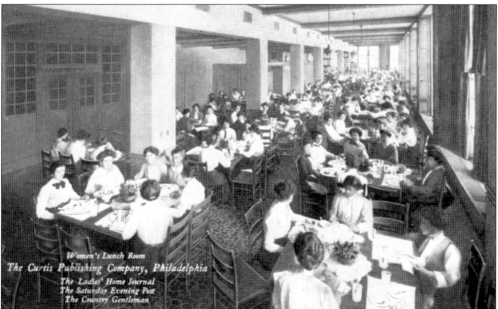

Curtis Publishing employed many women in the production and circulation of its popular magazines. The enlightened employer provided a separate lunchroom (above) and other facilities for women in its Washington Square building. However, the Curtis code of conduct apparently was strict. The company reportedly fired 15 young women in 1913 for dancing the "Turkey Trot" during their lunch break. (Free Library of Philadelphia, Print and Picture Collection.)

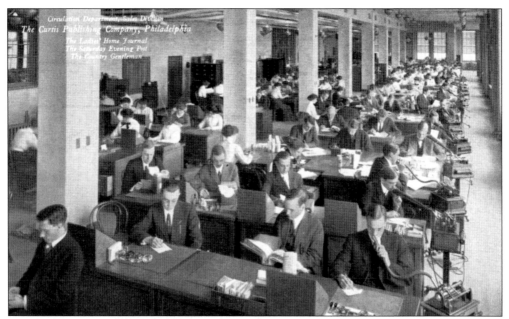

Initially all aspects of the Curtis publishing operation—from editing to the actual printing of the magazines—were performed in its Washington Square building. The structure was divided into four functional units. The publication unit facing Sixth Street housed the administrative, editorial, advertising, and circulation departments. Manufacturing took place in two units facing Walnut and Sansom Streets, respectively. A "convenience belt," containing stairways, elevators, restrooms, and utilities, insulated the publication unit from the noise of the printing presses. The busy circulation department (above) supplied the vital link between the *Saturday Evening Post*, *Ladies Home Journal*, and other Curtis magazines and their millions of subscribers. The company's plush, if compact, directors' room is pictured below. (Free Library of Philadelphia, Print and Picture Collection.)

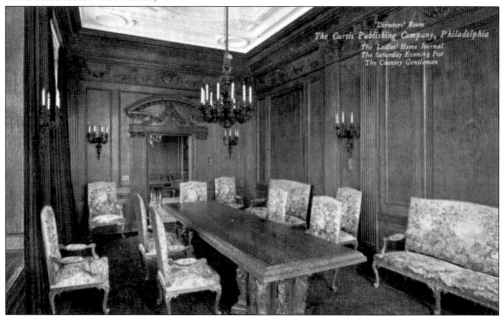

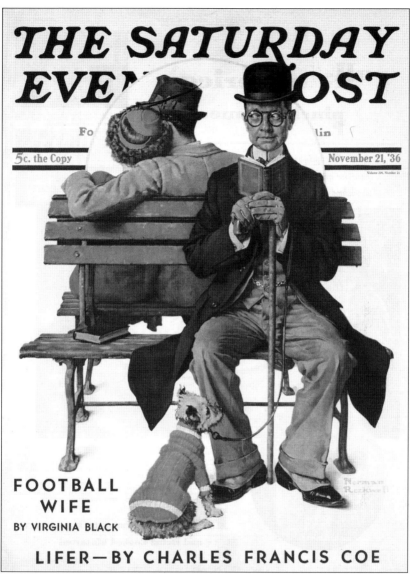

THE SATURDAY EVENING POST

Fo...lin

5c. the Copy

November 21, '36

Volume 209. Number 21

FOOTBALL
WIFE
BY VIRGINIA BLACK

LIFER—BY CHARLES FRANCIS COE

In 1897, Cyrus H. K. Curtis purchased the *Saturday Evening Post*, a floundering weekly published in Philadelphia since 1821, for $1,000. He redesigned it as a weekly magazine covering business, public affairs, and romance. Following the formula that had propelled his *Ladies Home Journal*, Curtis hired leading writers and illustrators for the *Post*. Perhaps his shrewdest move was hiring editor George Horace Lorimer. Under Lorimer, the *Post* became Curtis's flagship, reaching one million in circulation in 1908 and two million in 1913. Unapologetically middle brow, the *Post* aimed for the largest rather than the smartest audience. Works by well-known writers such as F. Scott Fitzgerald and Sinclair Lewis appeared beside stories, serials, and cartoons of lesser-known writers. Covers featured the folksy art of illustrator Norman Rockwell. Curtis kept the *Post*'s price low to build circulation and attract advertisers. By 1927, annual advertising revenue topped $50 million. However, the once mighty *Post*, like other general circulation magazines, was unable to counter television's appeal to its advertisers. It expired in 1969. A version of the *Post* was revived in 1971 as a quarterly focusing on health care. (Free Library of Philadelphia, Print and Picture Collection.)

Dutch-born Edward Bok took over Curtis's *Ladies Home Journal* in 1889. Bok proved a brilliant editor. By 1900, the *Journal* was the country's best-selling magazine. Curtis assigned Bok to commission works for the publisher's new building. However, obtaining a suitable mural for the 1,000-square-foot lobby wall proved an unexpected challenge. One artist Bok selected died. Others refused or Bok rejected their proposals. When the building was completed the foyer wall remained unadorned (below). Finally, Bok settled on favrile glass tile as the ideal medium for the mural. He contracted with Louis Comfort Tiffany for the glasswork and prevailed upon artist Maxfield Parrish for the design. Parrish's three-by-nine-foot sketch of a "dream garden" became the template Tiffany's craftsmen used to create the mural. (Free Library of Philadelphia, Print and Picture Collection.)

Maxfield Parrish, who collaborated with Louis Comfort Tiffany to create the *Dream Garden* in the Curtis Building, was born in Philadelphia in 1870. He attended Haverford College intent on becoming an architect but left to study art at the Pennsylvania Academy of the Fine Arts. Parrish won fame for his imaginative illustrations, which blended luminescent colors, photorealistic subjects, and romantic fantasy. (Free Library of Philadelphia, Print and Picture Collection.)

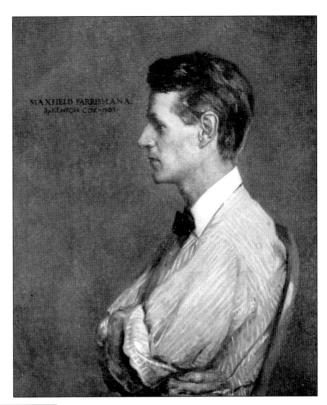

Louis Comfort Tiffany used Maxfield Parrish's design to create the brilliantly colored iridescent mosaic mural *Dream Garden* in the Curtis Building lobby. Born in New York in 1848, the son of jeweler Charles L. Tiffany, he gained a reputation as a painter, craftsman, and designer. Tiffany was best known for his use of iridescent colored glass, which he named favrile from the Latin *faber* or craftsman. (Library of Congress, Prints and Photographs Division.)

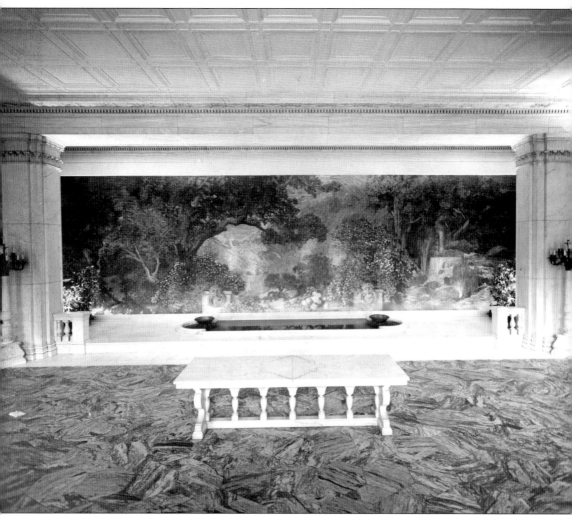

The spectacular *Dream Garden* mosaic mural above adorns the lobby of the Curtis Publishing building on Washington Square. It lends credence to the company's ambition to "put good art within the comprehension of a large public." Edward Bok, senior editor and son-in-law of founder Cyrus H. K. Curtis, enlisted artist Maxfield Parrish and Louis Comfort Tiffany, a master of glass art, for the task. Tiffany studios used Parrish's painting of a mystical dream garden to produce the mosaic with more than 100,000 pieces of shimmering hand-fired glass in 260 colors. Although the mosaic was critically acclaimed and an immediate public favorite, neither Parrish nor Tiffany was fully satisfied with the work of his collaborator. In 1998, outraged Philadelphians thwarted the building owner's attempt to sell the *Dream Garden* to magnate Steve Wynn for his Las Vegas casino. A $3.5 million philanthropic grant enabled the Pennsylvania Academy of the Fine Arts to purchase the mosaic and maintain it in the Curtis lobby. (Free Library of Philadelphia, Print and Picture Collection.)

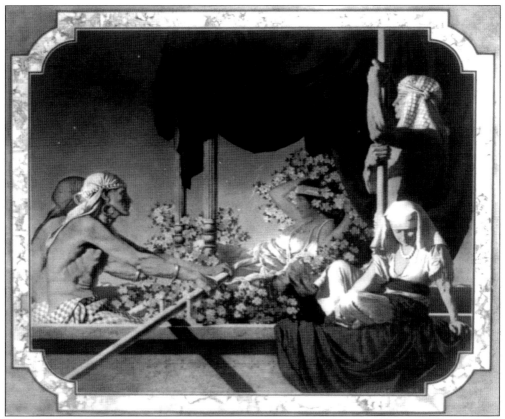

Maxfield Parrish was one of the most popular artists of his day. In addition to Cyrus H. K. Curtis, for whom he conceived the *Dream Garden*, Parrish's patrons included the Vanderbilt, Whitney, Astor, du Pont, and Hearst families. His illustrations, including *Cleopatra* (above), graced the covers of leading magazines. A 1925 survey ranked Parrish, with Vincent van Gogh and Paul Cezanne, among the greatest artists of all time. (Library of Congress, Prints and Photographs Division.)

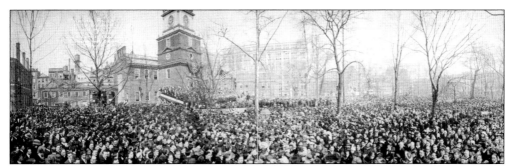

The Philadelphia Home Defense Committee, appointed by Mayor Thomas B. Smith in March 1917, rallies in Independence Square. After aiding a naval recruiting campaign, the committee coordinated efforts to assist the war effort and the families of service members during World War I. The Curtis Publishing building is visible in the background. (Library of Congress, Prints and Photographs Division.)

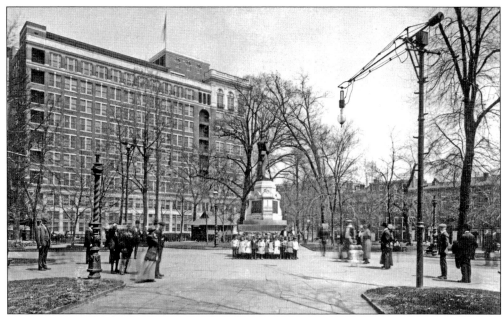

It is April 1913 and a ceremony is in progress at the Washington Grays monument in the center of Washington Square. The Curtis Publishing building (left) had been completed a year earlier. The houses of Lawyers' Row can be seen along Sixth Street to the right of Curtis. These structures would be soon leveled for construction of the Penn Mutual building. (Philadelphia City Archives, PhillyHistory.org.)

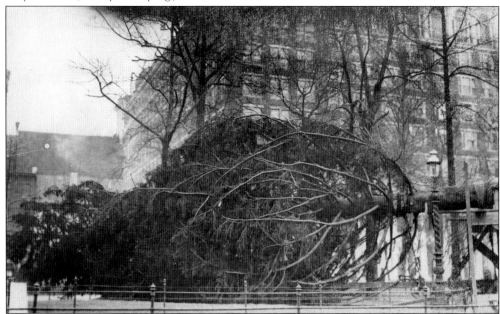

A Christmas tree is being set up in the middle of Washington Square in this 1913 photograph. The Curtis Publishing Company building, completed in 1912, supplies the backdrop. Note the houses to the left of Curtis remaining in the 600 block of Walnut Street. The Curtis building would not be extended to envelop the entire block until 1921. (The Library Company of Philadelphia.)

Walter Burns (W. B.) Saunders, son of an impoverished minister, founded W. B. Saunders Company, a medical publishing house, in 1888. Its first location, a 1,000-square-foot-space at 33 South Tenth Street, was selected due to its proximity to Jefferson Medical College and Hospital, source of many early Saunders authors. Saunders was well positioned to inform the medical profession about the meaning and uses of breakthrough medical discoveries that occurred in the late 19th century. Successful publications such as the *American Textbook of Surgery* led Saunders to seek more space for his company. He moved first to 913 Walnut Street in 1891 and to 925 Walnut (below) the following year.

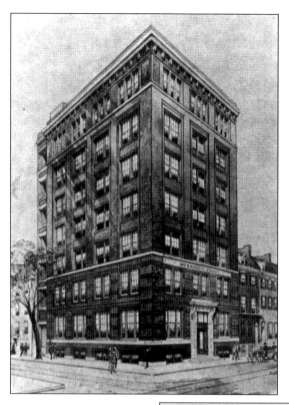

By 1912, W. B. Saunders had become one of nation's foremost medical publishers. It was time to join Curtis and the Farm Journal in Washington Square's building boom. Saunders erected a seven-story marble-trimmed building on the west side of the square at Locust Street designed by Henry A. Macomb. The building swayed rhythmically when the printing presses installed on the upper two floors were fully engaged.

W. B. Saunders achieved national attention, notoriety in some circles, by publishing *The Kinsey Report* in 1948. President Lawrence Saunders believed the study of human sexuality by Dr. Alfred Kinsey (right) had scientific merit. Who better than a respected medical publisher to bring it to the public? Some colleagues feared for Saunders's reputation. Public opinion was divided. The work became an immediate best seller, and Saunders could scarcely meet the demand.

The nattily attired "sidewalk superintendents" seem attracted by an excavation project in the middle of Locust Street at Washington Square in the 1915 photograph below. Perhaps they are employed by W. B. Saunders, whose building on the corner had been recently completed. The stylish doorway of a residence demolished for construction of the Saunders building is pictured at right. The structures to the west of the Saunders building would later be demolished to provide parking space. Today the residential character of the corner has been restored by conversion of the Saunders building to condominiums. (Philadelphia City Archives, PhillyHistory.org.)

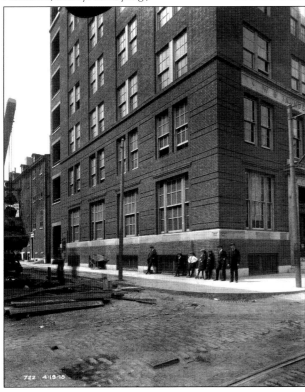

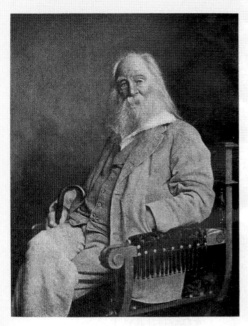

LEAVES OF GRASS
By
⚘ WALT WHITMAN ⚘

Including a Fac-simile auto-
biography variorum readings
of the poems and a department
of Gathered Leaves

Philadelphia.-
DAVID McKAY ·
Washington Square.

David McKay, age 11, emigrated from Scotland with his family in 1860. He began his publishing career two years later at J. B. Lippincott. His life-long association with poet Walt Whitman began while McKay was employed by publisher Rees Welsh and Company. There he published Whitman's *Leaves of Grass* in 1881 following its suppression by a Boston publisher under threat from the state attorney general, who branded the work immoral. In 1882, McKay opened his own publishing company on Ninth Street. He moved the business to 610 South Washington Square in 1904 and shortly thereafter into a converted stable next door at No. 608. McKay's books spanned genres from literature to textbooks to children's tales. In later years the firm published comic books, including early editions of Walt Disney's *Mickey Mouse*.

The *Farm Journal*, one of Washington Square's most successful publications, was launched in 1877 by Wilmer Atkinson, a Quaker born on a small farm near New Hope. His goal was to inform and entertain farmers and their families "within a day's ride of Philadelphia." In his first issue (below) Atkinson pledged to accept no advertisements for lottery swindles, cheap jewelry, or quack medical products. Subscriptions were 25¢ a year. To better understand the needs of his readers, Atkinson visited with farm families. He communicated directly to them in a clear, crisp writing style leavened by humor. Rather than courting advertisers, Atkinson concentrated on building the *Journal's* circulation. He recognized that a large readership would lure advertisers. (Farm Journal Media.)

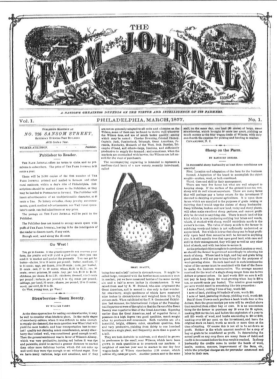

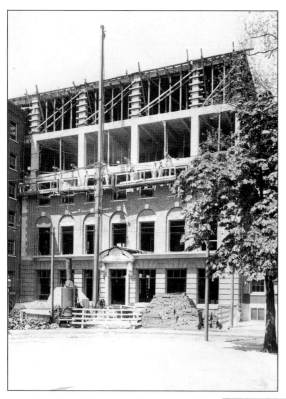

By 1912, the *Farm Journal* was prosperous enough to move from quarters on Race Street to a building that it commissioned on Washington Square. The handsome Colonial-style building by architects Morgan Bunting and Arthur Shrigley, shown during and after its construction, was erected on the site of the former Orange Street Meeting House in the southwest corner of Washington Square. Charles F. Jenkins, who became coeditor in 1896, was a key figure in the Washington Square Improvement Association's efforts to upgrade the square. The Farm Journal continues to publish, although it has relocated from the square. Its former home is now occupied by the Pennsylvania Hospital Health System. (Farm Journal Media.)

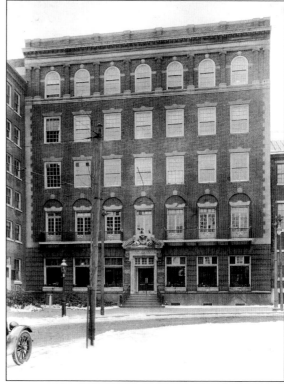

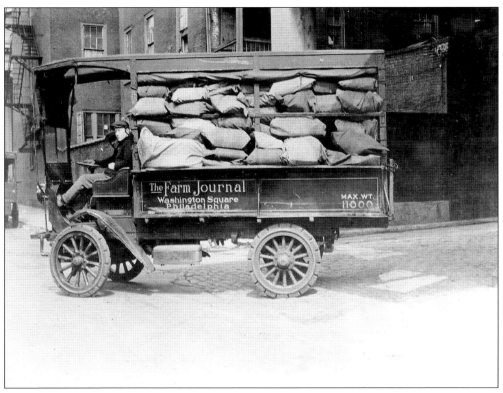

The *Farm Journal* extended its reach well beyond "a day's ride from Philadelphia" to become the world's largest agricultural magazine with a circulation of more than three million subscribers. An early delivery vehicle (above) takes magazines to the post office. Wilmer Atkinson used his publication as a platform to champion causes: rural free delivery of mail, postal savings banks, and the preservation of birds. Atkinson also understood the important role played by farmers' wives. He advocated sexual equality, female suffrage, and the adoption of labor-saving inventions in the home. The October 1931 issue of the *Journal* (right) focused readers' attention on the nation's war debt. (Farm Journal Media.)

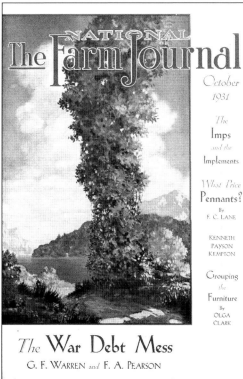

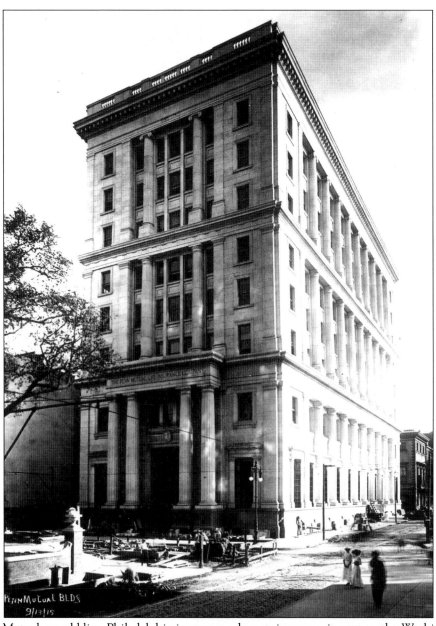

Penn Mutual, an old-line Philadelphia insurer, made a major commitment to the Washington Square neighborhood during the early 20th century when it purchased and razed several houses on the site of the old Walnut Street Prison on the square's east side. The life insurance company, founded in 1845 by hardware merchant John W. Hornor in an office barely 15 feet square, prospered remarkably over the ensuing 50 years. By 1912, Penn Mutual had outgrown its third quarters, a Victorian building at 921 Chestnut Street. Architect Edgar V. Seeler was engaged to design a building for the Walnut Street site that would afford the company room for future growth. The resulting white marble and limestone neoclassical structure rose 10 stories on the southeast corner of the square, matching the height of the Curtis Publishing building diagonally across Walnut Street. One resident maintained these buildings altered wind patterns in Washington Square. (Penn Mutual Archives.)

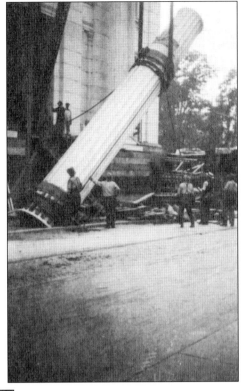

Workers (right) employ block and tackle to raise support columns for the pediment of the Penn Mutual Insurance Company building under construction at Sixth and Walnut Streets in this 1914 photograph. The entry's neo-Greek theme is echoed in the pilasters along the upper floors of the 10-story building. The granite and limestone structure conveyed an image of permanence and strength reassuring to the company's policyholders. This solidity is emphasized in the building's Walnut Street entry, where the fluted columns frame massive bronze doors in the evening exposure below. The building, the first of three erected by Penn Mutual in the 500 block of Walnut Street, was completed in 1914. (Right, the Library Company of Philadelphia; below, Penn Mutual Archives.)

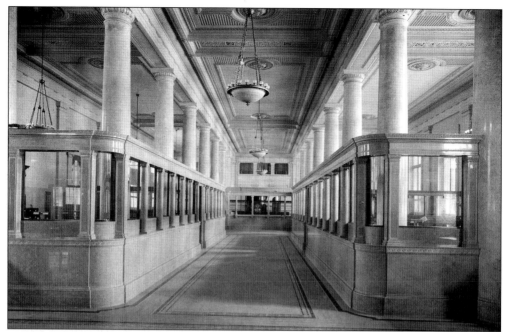

Architect Edgar V. Seeler's attraction to classical columns, evidenced in his exterior design of the Penn Mutual building, is reflected in the richly embellished main floor corridor of the building shown above. Marble-enclosed offices line both sides of the long elevator lobby. The 10-story company headquarters was completed in 1914. (Penn Mutual Archives.)

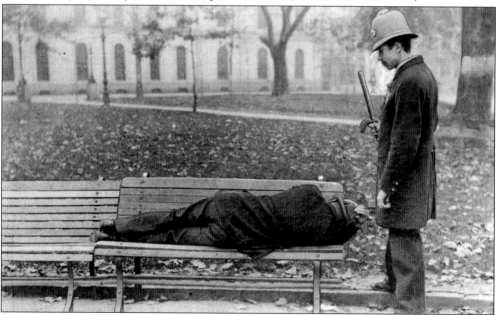

A rude awakening awaits this autumn snoozer on a Washington Square bench in 1904. Citizens had recently demanded the removal of loiterers who were harassing passersby in the square. The arched windows of the Italianate Renaissance Philadelphia Savings Fund Society building, completed in 1868, provide a backdrop on the west side of the square. (Free Library of Philadelphia, Print and Picture Collection.)

The Curtis Publishing and Penn Mutual Insurance buildings, two works by architect Edgar V. Seeler, were recognized in this 1916 photograph, which appeared in the yearbook of the Philadelphia chapter, American Institute of Architects. The first of Penn Mutual's three Walnut Street buildings (right) had been completed two years earlier. The first section of the Curtis building (left) had been occupied since 1912. Seeler attended the city's Central High School before studying architecture at the Massachusetts Institute of Technology and the Ecole des Beaux-Arts in Paris. His other projects included the First Baptist Church of Philadelphia at Seventeenth and Sansom Streets in 1899 and Hayden Hall at the University of Pennsylvania in 1895. (Free Library of Philadelphia, Print and Picture Collection.)

Matthew Carey was one of America's earliest book publishers. Born in Dublin in 1760, Carey prudently left Ireland after publishing articles critical of its British rulers. He met Benjamin Franklin in Paris and later immigrated to Philadelphia. In 1784, he founded Matthew Carey and Sons publishers, financed in part by a loan from the Marquis de Lafayette. The firm published general titles, including the first English edition of *Cinderella*, but later specialized in medical books such as *Gray's Anatomy*. It evolved into the firm Lea and Febiger, which erected an Italian palazzo–style building at South Washington Square and Sixth Street in 1925. Pictured below in 1926, the building houses an art gallery today. (Free Library of Philadelphia, Print and Picture Collection.)

This striking wrought-iron gate at the entrance to the 1925 Lea and Febiger building at 600 South Washington Square was produced on the forge of Samuel Yellin Ironworks. The work of this Polish-born artistic blacksmith, who lived from 1885 to 1940, adorns buildings and homes throughout the city. The lacy delicacy of Yellin's gate serves to disguise its protective function. (Independence National Historical Park.)

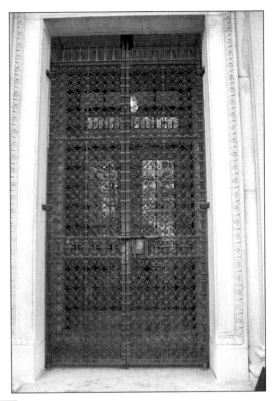

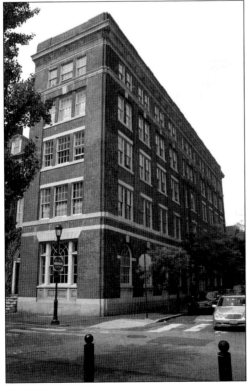

After failing in a bid to purchase the Athenaeum of Philadelphia building for $75,000, the American Gas Company erected this five-story Georgian-style office building on the West Washington Square at Locust Street in 1909. The site was formerly occupied by a four-story house constructed in 1825 by Langdon Cheves, president of the Second Bank. Shakespeare scholar Horace Howard Furness later lived in the house.

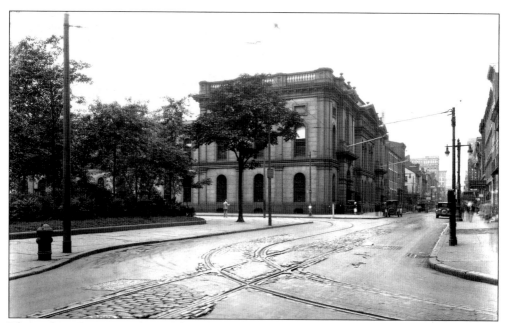

This is the intersection of Seventh and Walnut Streets in 1927. The Philadelphia Savings Fund Society is at center and Washington Square to the left. Here the Philadelphia Fountain Society erected its first fountain in 1869. The fountain was moved across the square in 1916 because a team of horses drinking at the fountain might block two streetcar lines. (Philadelphia City Archives, PhillyHistory.org.)

In 1924, the *Catholic Standard and Times* (CS&T) joined the migration of publishers to Washington Square. The weekly newspaper of the Roman Catholic Diocese of Philadelphia, begun in 1866, set up shop at 610 South Washington Square. The building, seen here, a few doors west of Lea and Febiger publishers, had formerly housed publisher David McKay. The photograph was taken just before the newspaper relocated in 1954. (Philadelphia Archdiocesan Historical Research Center.)

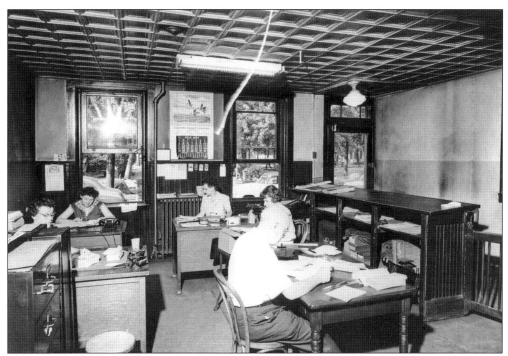

The Catholic Standard and Times combined its editorial and production functions within a single building. Here was ample space for the pressroom (below) at the rear of the building, while the editorial staff enjoyed natural light and a pleasant view of the square (above). Notice the linotype machines at the rear of the pressroom and pages being set in type in the foreground. The newspaper was formed by the combination of the *Catholic Standard* and *Times* newspapers. The *Catholic Standard* was first published in 1866 by Hardy and Mahoney at 505 Chestnut Street. (Philadelphia Archdiocesan Historical Research Center.)

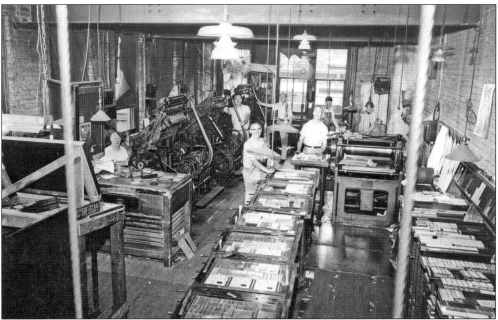

Shortly after Cyrus H. K. Curtis purchased the *Public Ledger* in 1913, he determined that the newspaper needed a larger building. The structure above was completed in 1924 on the site of the old Ledger building at Sixth and Chestnut Streets. The new building, designed by Horace Trumbauer in Georgian Revival style, blended with its neighbor at Sixth and Walnut Streets, the Curtis Publishing Company.

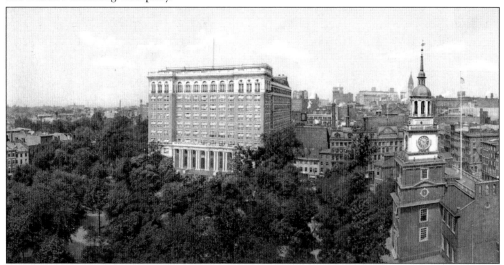

The photograph above looks west from Independence Square sometime after 1912 when the first segment of the Curtis Publishing Company (center) was completed. It shows the buildings on South Sixth Street to the right of Curtis that would fall to the wrecker's ball for construction of the new Public Ledger building in 1924. Washington Square lies to the left of the Curtis building. (Free Library of Philadelphia, Print and Picture Collection.)

"And no Walden sky was ever more blue than the roof of Washington Square this morning," mused Christopher Morley, writer and raconteur, while contemplating Henry David Thoreau. Morley, perhaps most noted for his novel *Kitty Foyle*, began writing a column for the *Evening Public Ledger* in 1918. The self-described "saunterer" lived for a time in a house at 704 South Washington Square (below on right), later dubbed the Christopher Morley Inn. His whimsical pieces celebrating city neighborhoods and common citizens were collected in a book titled *Travels in Philadelphia*. Morley moved on to New York where he helped found the *Saturday Review* and the Book of the Month Club. (Right, Free Library of Philadelphia, Print and Picture Collection; below, Philadelphia City Archives, PhillyHistory.org.)

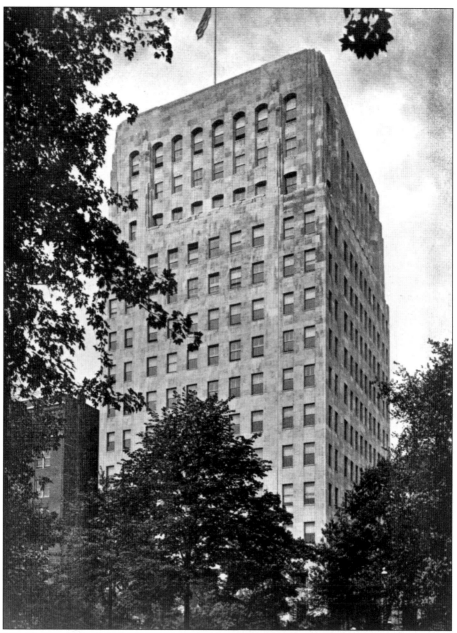

In 1929, N. W. Ayer and Son, the city's largest and nation's oldest advertising agency, moved into its signature building on Washington Square (above). The 14-story art deco–style landmark is located on the west side of the square just south of the Philadelphia Savings Fund Society. Architect Ralph Bencker adorned the building with imagery, both inside and out, that conveys the goals and purposes of the advertising industry. The exterior of the Indiana limestone building features spandrel reliefs, bronze doors, and eight massive carved figures around its upper floors. The images include the human figure to symbolize the creative mind, an allegorical figure to represent truth, an open book as the vehicle for advertising, and a winged bird to symbolize the widespread power of advertising. The "sculptures in the sky" were carved in situ by J. Wallace Kelly and Raphael Sabatini. (National Museum of American History, Smithsonian.)

Francis Wayland Ayer remains a legend in the advertising industry. In 1869, with a stake of $250, he founded the country's first advertising agency, naming it after his father, N. W. Ayer. He helped to transform the previously unsavory occupation of advertising into a respected profession. While raising ethical standards, Ayer shaped the growth of advertising as a force in the business world. Some of his early clients included Montgomery Ward, John Wanamaker, Singer Sewing Machines, and Pond's Beauty Cream. Ayer pioneered the use of market research, pictorial displays, trademarks, and slogans. His *American Newspaper Annual and Directory* became a standard reference work. The entwined doves below, symbolizing peace, adorn the interior of Ayer's art deco headquarters on Washington Square. (Right, Free Library of Philadelphia, Print and Picture Collection; below, National Museum of American History, Smithsonian.)

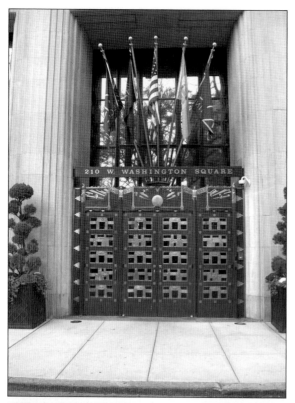

Architect Ralph Bencker commissioned J. Wallace Kelly to design the bronze doors of the N. W. Ayer building on Washington Square (left). The ornate doors are embellished with bas-reliefs that depict Ayer employees plying their trade. These figures are intended to convey the goals and purposes of the advertising industry. For example, the office workers below perform their routine albeit necessary daily labors consisting of typing, filing, and duplicating. Their robes, which lend an air of nobility to these humble tasks, may have been inspired by architect Bencker's recent visit to King Tut's Tomb. (National Museum of American History, Smithsonian.)

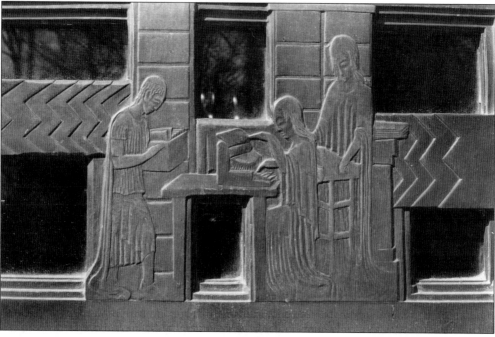

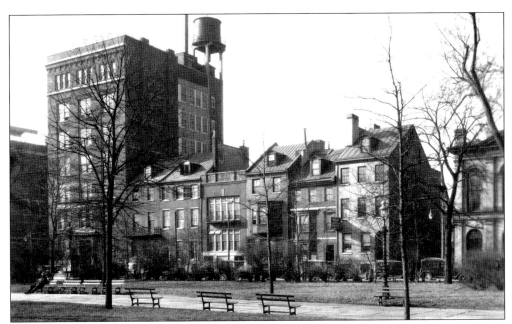

N. W. Ayer's desire for a Washington Square address led to the demise of the remaining residences on the west side of the square between Walnut and Locust Streets. The six properties seen here, to the right of W. B. Saunders publishers, built between 1795 and 1830, were razed for the Ayer construction in 1929. Although somewhat similar in appearance, they apparently were not part of a coordinated development. (National Museum of American History, Smithsonian.)

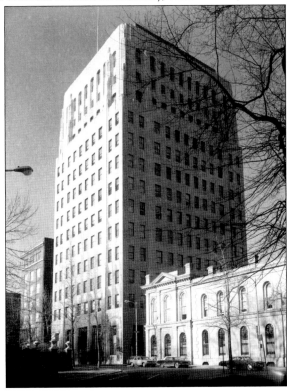

Seen here, N. W. Ayer's art deco tower rose between two earlier buildings on the west side of Washington Square in 1929. Medical publisher W. B. Saunders had completed its seven-story headquarters (left) in 1912 at the corner of West Washington Square and Locust Street. The Philadelphia Savings Fund Society home office (right) had been a fixture on the square since 1868. (Library of Congress, Prints and Photographs Division, HABS.)

N. W. Ayer pioneered the use of slogans and trademarks as an effective method for implanting and maintaining a product's image in the minds of its users and prospective users. The company was responsible for some of advertising's most effective campaigns and enduring slogans. A few of the more memorable are: "When it rains it pours" for Morton Salt in 1912; "I'd walk a mile for a Camel" for R. J. Reynolds Tobacco in 1921; "A diamond is forever" for De Beers in 1948; "Reach out and touch someone" for AT&T in 1979; "Be all you can be" for the U.S. Army in 1981; and "Snap! Krackle! Pop!" for Kellogg's cereals. (National Museum of American History, Smithsonian.)

96

JAMES MONTGOMERY FLAGG

He can't be beaten

IF it were possible to strip the Germans of their weapons and let our soldiers go at them with their bare hands, the war would be over by summer.

But winning the war isn't a question of courage alone. It is a matter of equipment. Our men must have guns and ammunition – food – supplies of all kinds – in quantities that stagger the imagination.

Only by furnishing these things promptly can the fighting be carried into the enemy's country.

The Kaiser says America has a yellow streak. Show him it is pure gold.

Buy Liberty Bonds. Buy them till it hurts. Buy them till it hurts.

There is immediate and urgent need for every dollar you can spare.

You are only *lending* not giving your money.

Your Government guarantees the return of your money with interest.

The Time to Act is Now!

This poster is contributed by
N. W. AYER & SON
as an expression of complete unity with the aims and purposes of our National Government.

LIBERTY LOAN COMMITTEE, THIRD FEDERAL RESERVE DISTRICT, LINCOLN BUILDING, PHILADELPHIA

N. W. Ayer employed its formidable powers of persuasion to sell war bonds during World War I. It was one of many public-interest campaigns the firm would mount over the years. The nation's oldest advertising agency, Ayer was responsible for many industry firsts. It pioneered the concept, now standard practice, that an advertising agency should work for its clients rather than for publishers. Ayer was one of the first firms to employ the new technology of radio, and was known for its use of fine art. Following a trend of its industry, Ayer relocated to New York in 1973. After losing some major clients and undergoing a series of mergers and acquisitions over the years, the firm was closed by its current owner, Publicis Groupe of France, in 2002. The Ayer building on Washington Square was converted into high-end condominiums in 2006, preserving much of the original décor. (Temple University Libraries, Special Collections.)

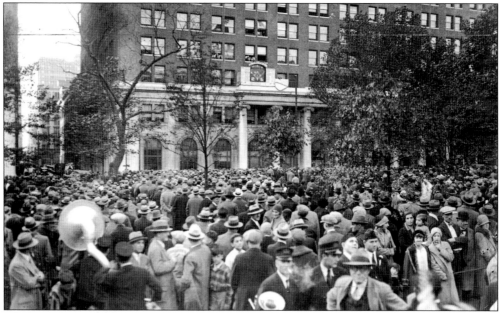

All eyes are on the Playograph perched atop the portico of the Public Ledger building at Sixth and Chestnut Streets during the fourth game of the 1929 World Series. The device used press box telegraph reports to re-create the game play-by-play on its screen. It proved a joyful day for local fans as the Philadelphia Athletics scored 10 runs in the seventh inning to defeat the Chicago Cubs. (Free Library of Philadelphia, Print and Picture Collection.)

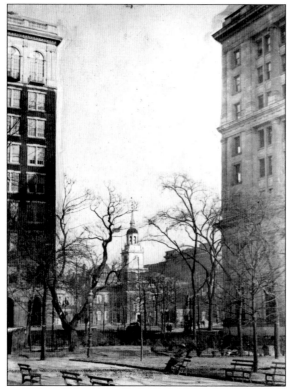

Bare trees and a solitary visitor accentuate winter's starkness in this January 1927 scene looking northeast from Washington Square. Independence Hall is framed by the imposing structures of the Insurance Company of North America (right) and Curtis Publishing Company (left). (Temple University Libraries, Urban Archives.)

The square's walks were rearranged in 1915 by the Washington Square Improvement Association to conform more closely to routes of pedestrian traffic, as shown in this 1930 diagram. This third redesign of the square's walk pattern, with minor changes, has carried forward to the present. (Independence National Historical Park.)

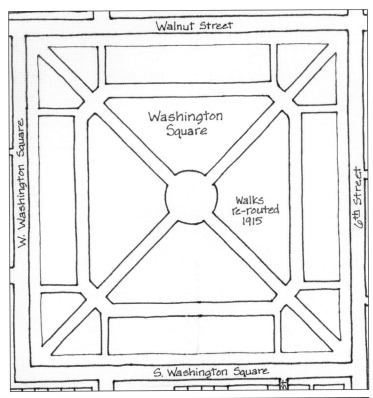

Two recently completed buildings appear in this 1931 aerial view of Washington Square. These are the top of the N. W. Ayer building on the west side of the square built in 1929 (bottom center) and the 16-story addition to the Penn Mutual Insurance Company building finished in 1931 at the northeast corner (center right). (Independence National Historical Park.)

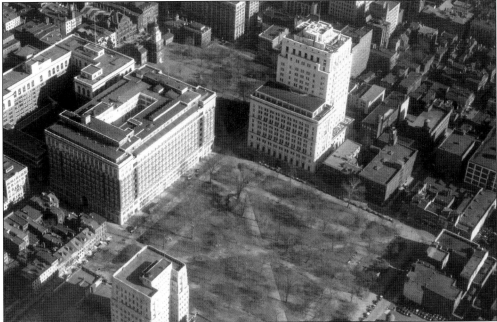

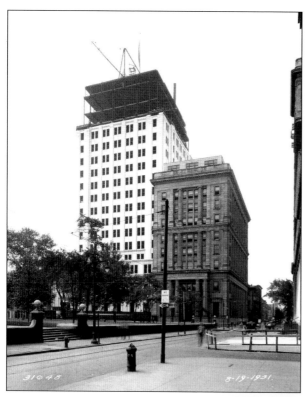

The plan for the first Penn Mutual Building at Sixth and Walnut Streets showed an open garden on its east side. However, the company prospered and an addition was planned for this space. Undeterred by the Great Depression, Penn Mutual opened the new building in 1931. The addition was designed by architect Ernest J. Matthewson. At 16 stories, it would be the tallest building in the vicinity of Washington Square, exceeding the height of the 14-story N. W. Ayer building completed on the west side of the square two years earlier. The photograph at left shows the partially finished Penn Mutual addition in 1931. The Penn Mutual building featured heavy bronze doors with bas-reliefs depicting various aspects of the insurance business. Below, an insurance agent pitches a policy to a young family. (Left, Philadelphia City Archives, PhillyHistory.org.)

Four

CHANGE AND RENEWAL
1933–2009

Development in the Washington Square neighborhood all but ceased between 1930 and 1950. Those who could afford to live elsewhere abandoned the old city as single-family residences were divided into rentals. In 1939, the old First Presbyterian Church on South Washington Square was demolished for a parking lot. In 1947, the city lopped off the square's northwest corner by allowing Seventh Street to run diagonally across a portion of the park.

But by midcentury, efforts were afoot to restore the area's former luster. Government had begun to recognize the value of preserving and restoring the Colonial city. Under reform Mayor Richardson Dilworth and his planner, Edmund Bacon, a master plan took shape in the 1950s to redevelop early Philadelphia. The city acquired vacant homes in the area around Washington Square and sold them inexpensively to private owners on condition that they be restored to historic standards. At the same time, the National Park Service assumed responsibility in 1951 for the area's city-owned historic buildings and began to rebuild and preserve them.

A movement, supported by local businesses, began raising funds to finally erect a fitting monument to the square's namesake and to honor the Revolutionary War soldiers buried there. In 1954, G. Edwin Brumbaugh, a respected restoration architect, was hired to plan the memorial. His design was implemented three years later. It included a life-size statue of George Washington and a memorial to the unknown soldier of the Revolution as well as a Colonial wall and Franklin-style lighting for the park.

These improvements in the square, much like those of the early 19th century, encouraged residential development. Builders responded not with the single-family houses of yore but with high-rise buildings. Hopkinson House, a 31-story apartment building, rose on South Washington Square in 1963 on the site of the old First Presbyterian Church. Along South Sixth Street, 19th century houses were leveled in 1964 and the high-rise Independence Place condominiums begun in 1982. Hopefully, destruction of the square's historic dwellings has abated. Instead its elegant early-20th-century commercial buildings are being converted to modern condominiums.

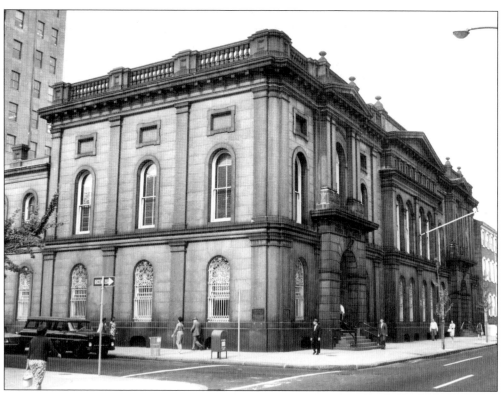

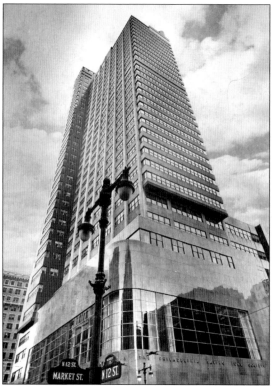

The Philadelphia Savings Fund Society continued its march westward as well as its tradition of significant architecture in 1932. The bank moved from its 1868 Washington Square headquarters (above) to the nation's first international-style skyscraper at Twelfth and Market Streets (left). The sleek 36-story building, designed by George Howe and William Lescaze, was hailed as an architectural breakthrough. Its sweeping polished granite base invited shoppers to the building's commercial space, while a lighted rooftop "PSFS" logo boldly proclaimed the bank's identity. The bank termed the building a "symbol to depositors that PSFS is safely weathering the depression." While the Philadelphia Savings Fund Society achieved this goal, it failed in 1992 during the savings and loan crisis. The landmark Market Street building was renovated and reopened in 2000 as a hotel, with many original features intact. (Free Library of Philadelphia, Print and Picture Collection.)

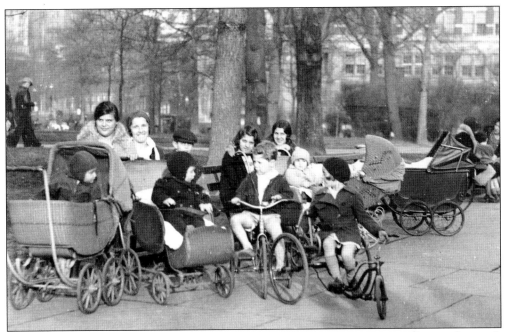

Philadelphia winters are not unremittingly cold and bleak. Here young mothers gather with their charges in the square to enjoy springlike breezes in mid-January 1932. The day was reported to be the warmest for that month in the city's history. The Curtis Publishing building appears through the trees on the right. (Temple University Libraries, Urban Archives.)

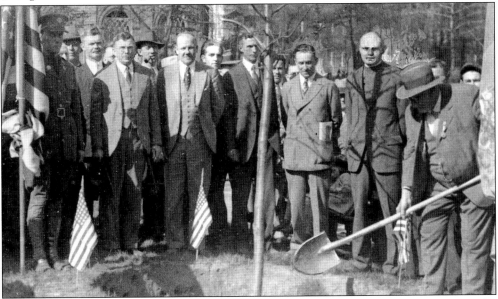

A red oak sapling honoring George Washington is planted in Washington Square by William J. Kleinheintz, president of the Philadelphia chapter of the National Association of Gardeners, in April 1931. The tree would be dedicated on the 200th anniversary of the first president's birth the following year. A memorial marking the 100th anniversary of Washington's birth was begun at the center of the square but never completed. (Temple University Libraries, Urban Archives.)

George T. Bisel Company, a law publisher, moved to 710 South Washington Square (left) in 1948, but its history in Philadelphia began much earlier. The firm traces its origin to 1876 when William F. Bisel began selling law blanks and stationery to lawyers. Upon William's death in 1881, his brother George continued to make the rounds of lawyers and judges throughout the state. In time, the firm added used law books and a proprietary line of law publications. The photograph below provides a wide-angle view of the Bisel building and other structures surrounding the southwest corner of Washington Square in 1959. (Left, George T. Bisel Company; below, Philadelphia City Archives, PhillyHistory.org.)

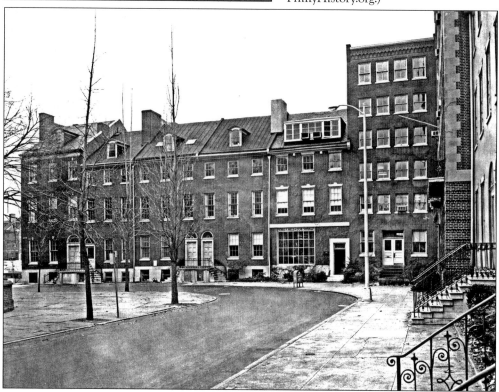

This 1930 photograph captures the classic neo-Greek lines of the First Presbyterian Church on South Washington Square at Seventh Street. The church, designed in 1822 by architect John Haviland, had been vacant for three years following the decision of its members to merge with another congregation to the west. It would be torn down in 1939 when the site was turned into a parking lot. A woman enters Washington Square joining other strollers in the undated photograph below looking north from Seventh Street. The iron fence of the First Presbyterian Church can be seen on the right. (Right, Philadelphia City Archives, PhillyHistory.org; below, Free Library of Philadelphia, Print and Picture Collection.)

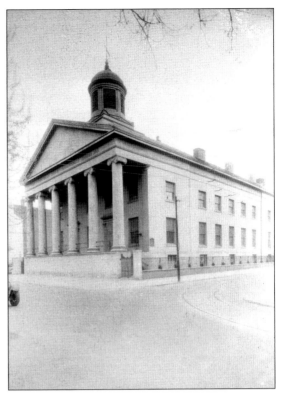

Given Washington Square's reputation as a publishing mecca, this open-air library on a park bench seems fitting. It was established in 1933 by the Playground Association for the many unemployed workers who frequented the square during the Great Depression. In the first week, 1,662 publications were borrowed. Magazines featuring distant countries and exotic places were reported to be the favorites. (Temple University Libraries, Urban Archives.)

Cars back up bumper to bumper along the west side of Washington Square in this 1946 photograph. Newspaper accounts attributed the traffic jam to a change initiated by the city to allow parking on the right side of the narrow street. The N. W. Ayer building is on the left. (Temple University Libraries, Urban Archives.)

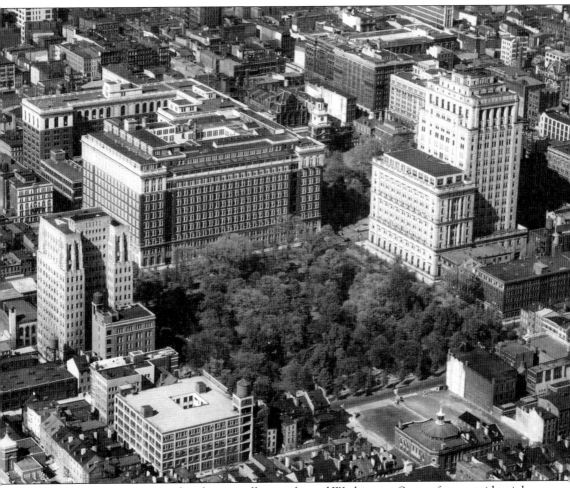

The homegrown companies that dramatically transformed Washington Square from a residential neighborhood to a business hub earlier in the century continued to flourish there in this 1940 aerial view. North across the tree-canopied square is the Curtis Publishing Company. The Penn Mutual Life Insurance Company original building and first addition are on the east side of square, to the right of Curtis. J. B. Lippincott may be seen to the south of Penn Mutual. Left of Curtis, on the west side of the square, is the 1929 art deco–style tower of N. W. Ayer advertising agency. South of Ayer are W. B. Saunders and the Farm Journal building at the square's southwest corner. The First Presbyterian Church, which had been demolished the previous year, stood on the vacant space on the south side of the square. The 31-story Hopkinson House apartments would rise on this site in 1963. (Free Library of Philadelphia, Print and Picture Collection.)

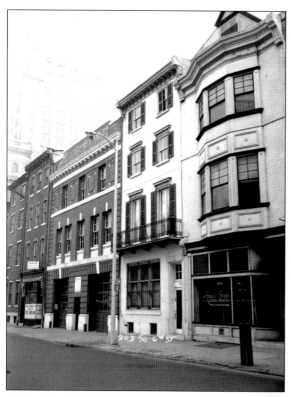

Several prominent residents inhabited houses in this block of South Sixth Street on the square's eastern flank before they were demolished in the 1960s. The commercial structure with bay windows at left, for example, was owned in unaltered form by Emmanuel Marquis de Grouchy (below), a distinguished French general forced into exile following his nation's defeat at Waterloo. Although ordered to march toward the sound of guns at Waterloo, Grouchy permitted his troops to be engaged by a Prussian rearguard, while a combined force of Prussians and English crushed Napoleon Bonaparte's army in the main battle. Grouchy took up residence at 245 South Sixth Street in 1818 and lived there until he was granted amnesty by France in 1821. (Left, Philadelphia City Archives, PhillyHistory.org; below, Free Library of Philadelphia, Print and Picture Collection.)

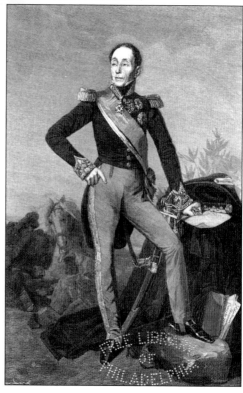

Another notable South Sixth Street resident was art critic John Canaday, early leader in the movement to revive Washington Square. While with the Philadelphia Museum of Art from 1953 to 1957, Canaday restored a house at 243 South Sixth Street (seen second from right in the top photograph on the previous page). A few years later, the city demolished the entire block. The first of two high-rises was completed there in 1982. (Free Library of Philadelphia, Print and Picture Collection.)

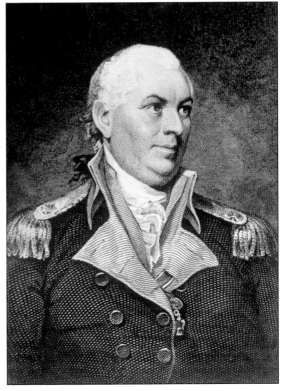

Commodore John Barry, Revolutionary War hero and father of the American Navy, lived at 237 South Sixth Street. The house at this address last served as a Good Humor depot (seen on the left, beyond firehouse, in the top photograph on the previous page) before being demolished for a parking lot in the 1960s. A native of Ireland, Barry offered his services to Congress when the Revolution began and commanded ships in important victories. (Library of Congress, Prints and Photographs Division.)

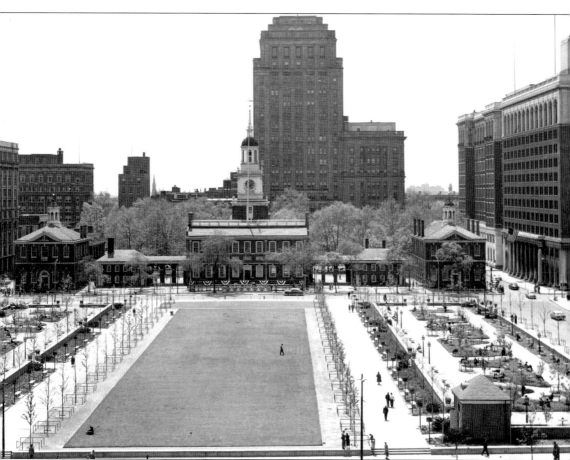

The sod has been laid and saplings planted in preparation for the dedication of the first section of Independence Mall north from Independence Hall in this 1955 photograph. Independence National Historical Park would be formally established the following year. Thirty-seven properties had occupied the block between Chestnut, Market, Fifth, and Sixth Streets before their demolition by the state. Many more buildings in the area would be demolished to create a large plaza as a setting for historic 18th-century buildings. Opponents questioned the wisdom of such wholesale demolition to create the mall and argued the city's historic fabric should be maintained. Washington Square can be glimpsed to the right in the space between the Penn Mutual and Curtis buildings. (ACE Group Archives.)

In 1938, Curtis Publishing launched *Jack and Jill*, a magazine for children 7–10. This July 1952 cover depicts the demolition project under way at the time to create Independence Mall in the block bordered by Chestnut, Market, Fifth, and Sixth Streets. Critics of the project contended that the area's historic buildings should be preserved. *Jack and Jill* is published today by the Children's Better Health Institute. (Independence National Historical Park.)

Field toilets stand at ready in preparation for a Boy Scout jamboree in Washington Square over the July 4 holiday in 1950. Judging by their number, a large turnout of Scouts was expected. It is uncertain whether the sponsors would later make any concession to modesty by shielding the facilities from public view. (Philadelphia City Archives, PhillyHistory.org.)

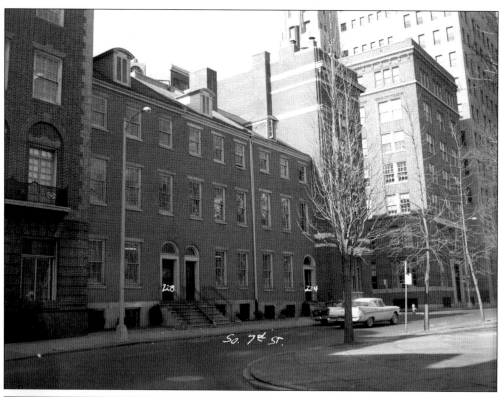

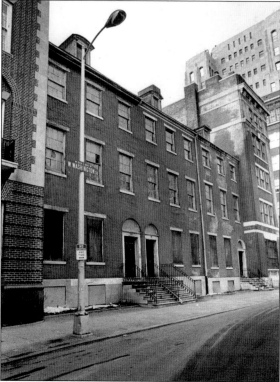

Thanks to the sturdy materials and skillful workmanship of a bygone era, the houses that remain on Washington Square have demonstrated a capacity to endure and adapt. The houses in these photographs, from 224 to 228 West Washington Square, were constructed between 1818 and 1823. They were built on speculation by merchant John Lisle and once housed prominent residents, including a mayor of Philadelphia. At the time of the 1959 photograph above, the houses provided commercial space for the Rohm and Haas Chemical Company, which had established its headquarters in the building at right at No. 222 in 1927. After Rohm and Haas relocated in 1965, the houses were eventually returned to residential use. The 1979 photograph at left predates their restoration. (Above, Philadelphia City Archives, PhillyHistory.org; left, Temple University Libraries, Urban Archives.)

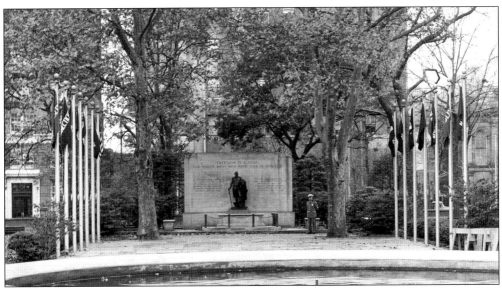

Architect G. Edwin Brumbaugh sited the memorial to the unknown soldier of the Revolution west of a central fountain. At center a statue of Gen. George Washington stands in front of a backdrop bearing the inscription "Freedom is a light for which many men have died in darkness." The phrase was written by John J. Pullen, an employee of Washington Square advertising agency N. W. Ayer. At the general's feet a stone sarcophagus holds the remains of an unknown Revolutionary soldier exhumed from the square's burial pits. Fourteen flagpoles for the banners of the 13 original colonies and the first American flag flank the memorial. The monument was dedicated in 1957. The eternal flame (right) that burns at the front of the monument was added for the nation's bicentennial in 1976. (Above, Fairmount Park Historic Resource Archive; right, National Museum of American History, Smithsonian.)

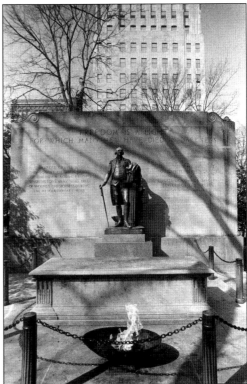

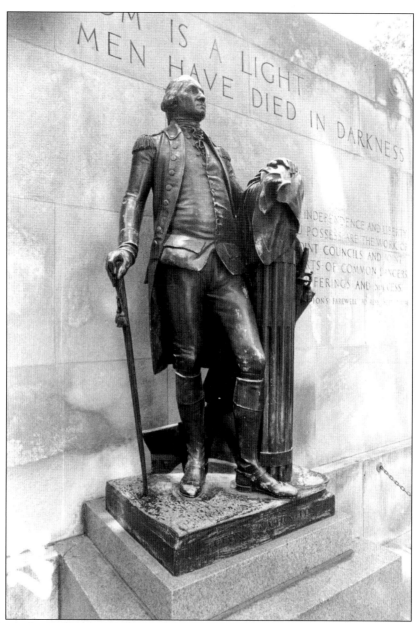

The life-size figure of Gen. George Washington at the center of the monument to the unknown soldier of the Revolution is a bronze cast of a marble statue of Washington by neoclassical French sculptor Jean Antoine Houdon. The figure who gazes across the burial ground toward Independence Hall, although uniformed, is clearly a man of peace. His sword is detached and placed to the side. He holds a walking stick in his right hand. His left hand rests on a column of fasces, symbolizing official authority and political unity. The plow at the general's feet alludes to the fifth-century Roman soldier Cincinnatus, who relinquished military power to return to a simple life of farming. Houdon traveled to America to make models of Washington. The cast was moved to the square from the Philadelphia Museum of Art in 1954. The original statue, commissioned by Thomas Jefferson in 1785, stands in the Virginia State Capitol. (Fairmount Park Historic Resource Archive.)

Architect G. Edwin Brumbaugh studied Colonial engravings to determine the appropriate streetlamps for his makeover of Washington Square. He designed a replica of the lamp invented by Benjamin Franklin. Franklin had modeled his lamp on those of 18th-century London. He noted, however, that the glass globes of these lamps quickly became clouded by smoke and were easily broken. Franklin corrected these flaws by designing a lamp with air holes and a funnel to prevent smoking and four panes of glass to permit easy repair. Brumbaugh modeled his wall (below) on a design used to enclose the burial grounds of Colonial churches. The redbrick walls were curved at the entrances to blend into the square's walkways and marked by pillars with marble caps. (Independence National Historical Park.)

G. Edwin Brumbaugh, the creative force behind the 1950s redesign of Washington Square and many other historic restorations, began his career as a residential architect unremarkably. He graduated from the University of Pennsylvania in 1913 with a bachelor of science degree in architecture and by 1916 had established a practice specializing in residential design. Over time, his interest in early American buildings, particularly the vernacular architecture of the Pennsylvania Germans, led Brumbaugh to focus his efforts on restoration. He found fertile ground in the historic buildings of the Middle Atlantic states, where he became a leading practitioner of restoration architecture. Among his projects were the Ephrata Cloister, the Daniel Boone Homestead, Grumblethorpe, and Gloria Dei Church. He also advised regarding the restoration of Independence Hall and designed Mayor Richardson Dilworth's 1957 house on the east side of Washington Square. Brumbaugh is pictured above at Pottsgrove Manor, the home of John Potts, founder of Pottstown. (Winterthur Library, Joseph Downs Collection)

Archaeologist Lt. Col. Duncan Campbell unearths the skull of a Revolutionary War soldier in November 1956. After five days of digging, a skeleton was discovered in the northwest corner of the square at a depth of six feet. The bones were reinterred in the square's memorial to the unknown soldier of the Revolution. Evidence suggested the remains were those of a soldier, rather than of a pauper, yellow fever victim, or other civilian buried in the square. Whether they belonged to a Continental or British soldier is less clear. Below, a winter storm blankets a Franklin lamp and the rest of the park in white following redesign of the square. (Temple University Libraries, Urban Archives.)

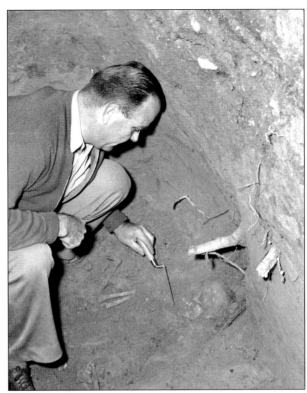

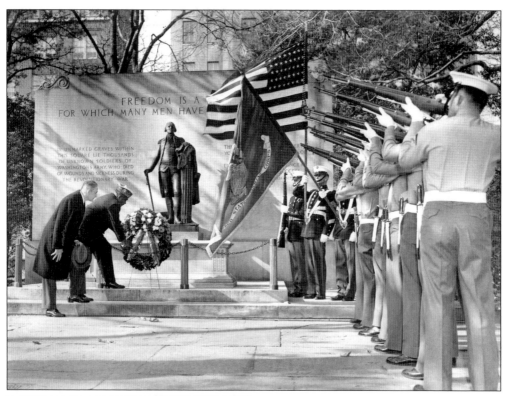

The city honors the unknown soldier of the Revolution on Veterans Day 1961. Mayor Richardson Dilworth and Dennis White, commander of the United Veterans Council, place a wreath at the memorial. Also participating are units from the Marine Corps barracks at the Philadelphia Naval Base. The sarcophagus holds the remains of a Revolutionary soldier. Its inscription reads, "Beneath this stone rests a soldier of Washington's army who died to give you liberty." At left, students of the McCall elementary school usher in Memorial Day with a visit to Washington Square in 1978. They are checking out the eternal flame, which was added to the memorial in 1976 to mark the nation's bicentennial. (Temple University Libraries, Urban Archives.)

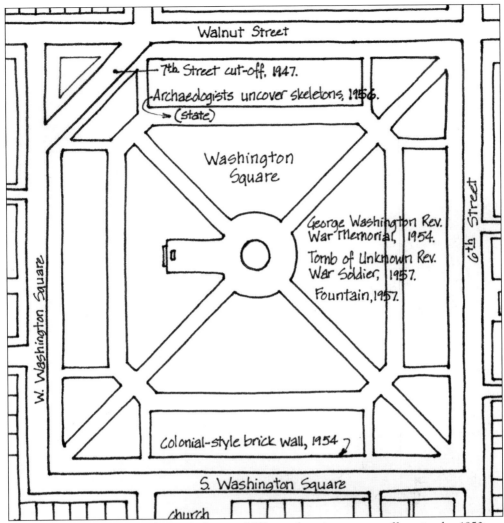

Walnut Street

7th. Street cut-off, 1947.

Archaeologists uncover skeletons, 1956.

(state)

Washington Square

George Washington Rev. War Memorial, 1954.

Tomb of Unknown Rev. War Soldier, 1957.

Fountain, 1957.

W. Washington Square

6th Street

Colonial-style brick wall, 1954

S. Washington Square

church

The movement to restore the city's Society Hill area lent impetus to efforts in the 1950s to improve Washington Square and commemorate the Revolutionary War soldiers buried there. This diagram highlights the changes. In 1953, a Washington Square Planning Committee representing firms and organizations near the square took the lead in planning and raising funds for the project. Architect G. Edwin Brumbaugh was engaged to modify the square for the memorial. His changes included the addition of a central fountain and a space for the memorial. A monument honoring the first president and an unknown soldier was dedicated in 1957. Brumbaugh surrounded the square with a low brick wall and installed Colonial-style lamps. Unfortunately, the city effectively lopped off the square's northwest corner in 1947 to improve traffic flow on Seventh Street. (Independence National Historical Park.)

Richardson Dilworth, reform mayor of Philadelphia from 1956 to 1962, championed efforts to preserve the Colonial neighborhood east of Washington Square. Under his leadership, a city-backed entity was formed to acquire the area's deteriorated housing stock and market the houses to buyers who agreed to restore them to their original condition. To emphasize his commitment to the revitalization of Society Hill, Dilworth moved into the neighborhood. (Temple University Libraries, Urban Archives.)

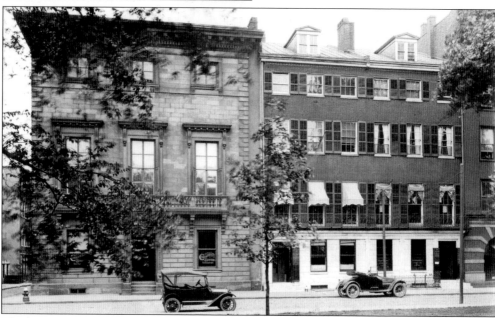

The houses at 221 and 223 South Sixth Street (above, right), which would be demolished in the mid-1950s to make room for Mayor Richardson Dilworth's house, were built in 1841, predating the Athenaeum of Philadelphia (left) by about six years. They appear inhabited and in good repair in this 1920s photograph but would be declared unsalvageable to make way for the mayor's faux Colonial dwelling. (Free Library of Philadelphia, Print and Picture Collection.)

Mayor Richardson Dilworth bought the two then-abandoned historic houses at 221 and 223 South Sixth Street (right). Despite the criticism of preservationists, he demolished these structures to erect the handsome double-wide faux Colonial house (below) in 1957. The Dilworth House, now also deserted, significantly placed the mayor in the forefront of the successful movement to restore historic Society Hill. The neighborhood, once home to the city's elite, had become decrepit, filled with crumbling houses and abandoned stores. Ironically, modern preservationists are fighting efforts by the current owner to demolish most of the Dilworth House to build a 16-story condominium tower. (Right, Library of Congress, Prints and Photographs Division, HABS; below, Ted Savage.)

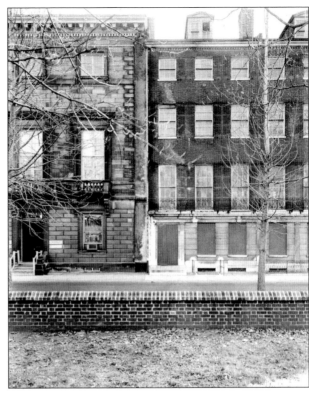

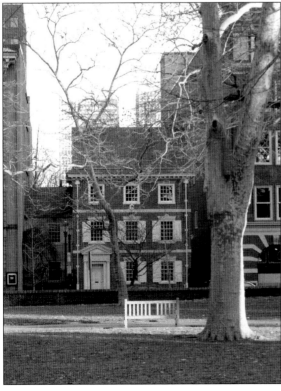

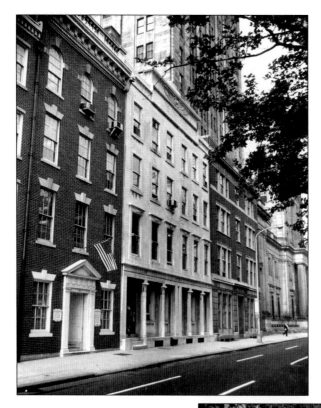

The 500 block of Walnut Street just below Washington Square is seen between construction of the Penn Mutual first addition in 1931 and the company's glass tower in 1975. The 1838 Pennsylvania Fire Insurance Company with its white front and Egyptian Revival design by architect John Haviland continued to be an eye-catcher. This building would be demolished along with the others and its facade incorporated into the tower in 1975. (Free Library of Philadelphia, Print and Picture Collection.)

The final member of Penn Mutual Insurance Company's triumvirate of buildings in the 500 block of Walnut Street was completed in 1975. The 22-story structure by architect Mitchell/Giurgola adjoins the company's 1931 addition and incorporates the facade of the 1838 Pennsylvania Fire Insurance Company that stood on the site. Penn Mutual began to move out of the city in 1986 and is now based in suburban Horsham. (Library of Congress, Prints and Photographs Division, HABS.)

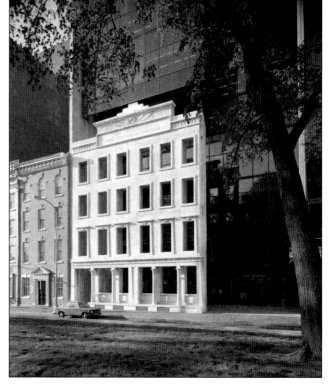

These young women, who are employed at a nearby bank, enjoy their lunch break during a pleasant summer day at Washington Square's central fountain in this 1968 photograph. They appear to be oblivious to the ceremony to their rear at the Tomb of the Unknown Soldier of the Revolution. (Temple University Libraries, Urban Archives.)

This memorial in the northeast quadrant of Washington Square honors Thomas M. (Tom) Foglietta, a local congressman, as a "champion of historic preservation." The bas-relief bust by Zenos Frudakis was installed in 2000. While a member of Congress, Foglietta advocated on behalf of federal funding to protect Independence Hall, Washington Square, and other historic sites. (Fairmount Park Historic Resource Archive.)

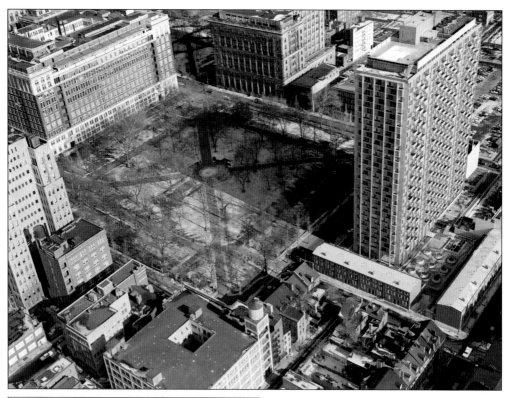

High-rise living came to Washington Square in 1963 in the form of Hopkinson House on the south side of the square in the space formerly occupied by the First Presbyterian Church and houses. Architect Oskar Stonorov designed the 31-story apartment tower (above, on the right). To help the concrete monolith blend into the surrounding neighborhood, Stonorov flanked it on two sides with 18 semitraditional brick row houses. Residents of the new apartments (left) had access to a rooftop swimming pool and stunning views of the city. Philadelphia's 1901 city hall looms in the distance. (Temple University Libraries, Urban Archives.)

Houses on the east side of Washington Square between Locust and South Washington Square were demolished during the 1960s, a period when urban renewal trumped preservation. Notable residents had included Emmanual Marquis de Grouchy, the French general, and John Canaday, the art critic who lovingly restored his property. Several years later, Independence Place, a two-building condominium development, rose there. The first building is under construction in this 1981 photograph from the square. (Temple University Libraries, Urban Archives.)

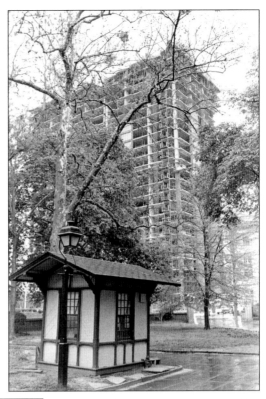

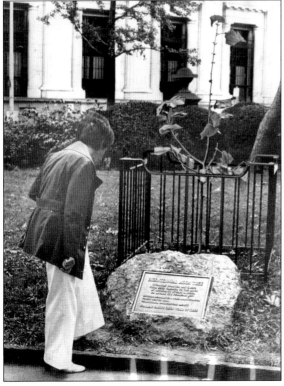

In addition to the many earthly shade trees within its borders, Washington Square is the home of a sycamore with an extraterrestrial heritage. The "bicentennial moon tree" was planted on May 6, 1975, after growing from a seed carried to the moon by astronaut Stuart A. Roosa on *Apollo XIV* in 1971. It honors "earth's green world of trees." (Temple University Libraries, Urban Archives.)

125

Youngsters enjoy the playground installed in the square's southwest corner in this 1976 photograph. However, their cries of youthful enthusiasm did not amuse complaining residents, one the British consul, on the south side of the square. A year later the *Evening Bulletin* reported, "The gracious tranquility of Washington Square has been restored." The city moved the equipment to a South Philadelphia playground. (Temple University Libraries, Urban Archives.)

A neighbor chats with a Fairmount Park guard on the east side of the square on an autumn day in 1972. The Fairmount Park Commission, which operates the city's park system, assumed responsibility for the square in 1916. The commission's park guard force was merged with the city police department in 1972, but members continued to wear their distinctive uniforms for some time thereafter. (Philadelphia City Archives, PhillyHistory.org.)

BIBLIOGRAPHY

Dallett, Francis James. *An Architectural View of Washington Square*. Philadelphia: Athenaeum, 1964.

Dusseau, John L. *An Informal History of the W. B. Saunders Company*. Philadelphia: W. B. Saunders Company, 1988.

Freeman, J. Stuart, Jr. *Toward a Third Century of Excellence: An Informal History of the J. B. Lippincott Company*. Philadelphia: J. B. Lippincott Company, 1992.

Frey, Carroll. *Philadelphia's Washington Square*. Philadelphia: Penn Mutual Life Insurance Company, 1952.

Frey, Carroll. *The First Air Voyage in America*. Philadelphia: Penn Mutual Life Insurance Company, 1943

Hochheiser, Sheldon. *Rohm and Haas, History of a Chemical Company*. Philadelphia: University of Pennsylvania Press, 1986.

Holy Trinity Roman Catholic Church. *A Retrospect of Holy Trinity Parish, 1789–1914*. Philadelphia: 1914.

Jenkins, Charles Francis. *Of Washington Square (Publishers' Square)*. Philadelphia: Private Printing, 1912.

Kalfus, Ken. *Christopher Morley's Philadelphia*. New York: Fordham University Press, 1990.

McCall, Elizabeth B. *Old Philadelphia Houses on Society Hill, 1750–1840*. New York: Architectural Book Publishing Company, 1966.

N. W. Ayer. *Washington Square*. Philadelphia: N. W. Ayer and Son, 1957.

Penn Mutual Life Insurance Company. *Chronicles of the Penn Mutual Life Insurance Company of Philadelphia*. Philadelphia, 1922.

Rabzak, Denise R. *Washington Square: A Site Plan Chronology 1683–1984*. Philadelphia: Independence National Historical Park, 1987.

Toogood, Anna Coxe. *Cultural Landscape Report: Independence Square*. Philadelphia: Independence National Historical Park, 1998.

Weigley, Russell F. *Philadelphia: A 300-Year History*. New York: W. W. Norton, 1982.

www.arcadiapublishing.com

Discover books about the town where you grew up, the cities where your friends and families live, the town where your parents met, or even that retirement spot you've been dreaming about. Our Web site provides history lovers with exclusive deals, advanced notification about new titles, e-mail alerts of author events, and much more.

MADE IN THE USA

Arcadia Publishing, the leading local history publisher in the United States, is committed to making history accessible and meaningful through publishing books that celebrate and preserve the heritage of America's people and places. Consistent with our mission to preserve history on a local level, this book was printed in South Carolina on American-made paper and manufactured entirely in the United States.

This book carries the accredited Forest Stewardship Council (FSC) label and is printed on 100 percent FSC-certified paper. Products carrying the FSC label are independently certified to assure consumers that they come from forests that are managed to meet the social, economic, and ecological needs of present and future generations.

FSC

Mixed Sources
Product group from well-managed
forests and other controlled sources

Cert no. SW-COC-001530
www.fsc.org
© 1996 Forest Stewardship Council

Find *Your* Place in History.